IMAGES
of America

THE LINCOLN
MEMORIAL

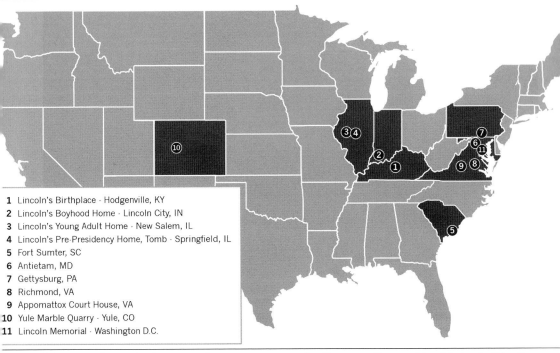

1 Lincoln's Birthplace · Hodgenville, KY
2 Lincoln's Boyhood Home · Lincoln City, IN
3 Lincoln's Young Adult Home · New Salem, IL
4 Lincoln's Pre-Presidency Home, Tomb · Springfield, IL
5 Fort Sumter, SC
6 Antietam, MD
7 Gettysburg, PA
8 Richmond, VA
9 Appomattox Court House, VA
10 Yule Marble Quarry · Yule, CO
11 Lincoln Memorial · Washington D.C.

This map shows the location of various events and milestones discussed in this book. The first four relate to the life of Abraham Lincoln and the places he lived. The next five cover some of the major sites of the Civil War. Number 10 indicates the quarry from which much of the memorial's building stone was mined. (Sarah Gilbert.)

ON THE COVER: Taken in the mid-1920s, this photograph shows the newly constructed and landscaped Lincoln Memorial during an era in which chauffeurs in fancy automobiles could transport visitors there for a quiet midday visit. While this scene today likely would include more people and fewer vehicles, the memorial and surrounding landscape have not significantly changed in the century since it opened. (Library of Congress.)

IMAGES
of America

THE LINCOLN
MEMORIAL

Kevin S. Schindler and Brian Anderson

ARCADIA
PUBLISHING

Published by Arcadia Publishing
Charleston, South Carolina

Printed in the United States of America

Library of Congress Control Number: 2021944673

For all general information, please contact Arcadia Publishing:
Telephone 843-853-2070
Fax 843-853-0044
E-mail sales@arcadiapublishing.com
For customer service and orders:
Toll-Free 1-888-313-2665

Visit us on the Internet at www.arcadiapublishing.com

*To Gretchen, Alicia, Sommer, Brandon, Lauren,
Aaron, Addison, Senna, and June.*
—Kevin S. Schindler

To Merry, Eric, Laura, and Mark.
—Brian Anderson

CONTENTS

Acknowledgments

Writers of books about Abraham Lincoln, the Civil War, Reconstruction, the civil rights movement, and the monuments and memorials related to those subjects, walk on thin ice. The historical record about the people who lived in those long-ago times and the events in which they participated is incomplete and imperfect. In writing this book, we did our best to base our account on the most reliable factual record we could find about the origins, design, construction, and usage of the Lincoln Memorial over the last 100 years.

Nevertheless, we know that some readers might take issue with our description or interpretation of events described in this book. We are happy to stand corrected if we are wrong about something. We are also happy to engage in constructive conversations with people having different viewpoints. That is how Abraham Lincoln approached disagreements regarding matters far more consequential than the details of a book. We can all learn from his example.

We appreciate the efforts of many people who helped make this book possible. For supplying images and information: Amanda Nelson, university archivist, Wesleyan University; Laura J. Anderson, director and regional curator, National Park Service's Museum Resource Center; Carol Highsmith, who donated myriad photographs of historically important Washington, DC, sites to the Library of Congress; Meghan Harmon, reference librarian, and Megan Klintworth, iconographer, at the Abraham Lincoln Presidential Library and Museum; and Wayne Hammond at the Chapin Library at Williams College.

For creating maps: Sarah Gilbert of Lowell Observatory.

For commenting on early drafts: National Park Service ranger Jennifer Epstein Rudnick (also known as "Ranger Jen"), director of Hunter College's Roosevelt House Public Policy Institute Harold Holzer, and Ford's Theatre Society's director of education and interpretation Sarah Jencks. Other commenters/supporters include Danielle Adams, Laura Chavez Anderson, Rich Bohner, Mary DeMuth, Dave Eicher, Jeff Hall, Madison Mooney, Joe Sims, and Larry Wasserman.

We are grateful to our editors at Arcadia Publishing, Katelyn Jenkins and Caroline Anderson Vickerson, for helping us take this book from idea to publication.

Kevin Schindler would like to thank his mom and stepdad, Dick, for a memorable research trip to the Abraham Lincoln Presidential Library and Museum as well as Donnie, Terry, Kim, and their families.

Unless otherwise indicated, images in this book appear courtesy of the Library of Congress (LOC); National Archives (NA); National Park Service (NPS); Wesleyan University Library, Special Collections & Archives (WU); or Kevin S. Schindler (KS).

INTRODUCTION

The Lincoln Memorial is one of those rare places known by people around the world, a symbol of the United States and of its capital city, Washington, DC. The memorial's stature is comparable to that of other world-class sites on every continent—the Arc de Triomphe in Europe, the Great Wall in Asia, the pyramids in Africa, and the Christ the Redeemer statue in South America. The Lincoln Memorial serves multiple functions. It is a memorial to Abraham Lincoln as a person and as a powerful national leader. It is a monument of the Civil War. Above all, it is a celebration of the reunification of the nation in the decades following that war and a symbol of America's aspirations in the early 20th century. But the Lincoln Memorial, by design, is not a celebration of the historical act for which President Lincoln today is most known—freeing Black Americans from slavery.

Abraham Lincoln was a complex person—neither the deity of his most devoted fans, nor the devil of his most animated detractors. Like all people of the eras in which they live, Lincoln was, despite his strengths, a product of his times. He embodied the knowledge, beliefs, assumptions, and limitations of the early to mid-19th century. While he was more supportive of civil rights for Black Americans than many others of the period, his positions on those issues were viewed as inadequate by some abolitionists of his time, and they fall far short of the standards of most people living today. Likewise, Lincoln's policies toward Native Americans included forced relocations and massacres—consequences that are condemned today.

Designing memorials to deceased leaders and monuments to events of historical importance is always a complicated and controversial endeavor. Different contributors to the process invariably compete to have the site tell the story they want future generations of visitors to absorb. Accordingly, the debate over how Lincoln's memorial should portray him was intense, divisive, politically charged, and lengthy.

Republican politicians who controlled the federal government at the start of the 20th century ultimately decided where the Lincoln Memorial would be located, what it would look like, and what messages it would (and would not) emphasize. In their view, Lincoln's most important achievement was reuniting the country by winning the Civil War, thereby positioning the United States to become a rich and powerful country—and budding world empire—by the early 20th century. Lincoln's efforts to free enslaved people were viewed as less worthy of emphasis by the memorial's designers at a time when the politics and culture included a vigorous post-Reconstruction backlash against civil and political rights for Black Americans via discriminatory Jim Crow laws and the portrayal of the failed Confederacy as a heroic "Lost Cause." Consequently, Lincoln's views about slavery and his efforts to end it received only modest attention in the memorial. The memorial's designers instead sought to focus attention on the first Republican president's personal qualities of humility, wisdom, compassion, and eloquence, while reminding visitors of how he rose from humble origins to save the Union.

These views found their way into the location and design of the Lincoln Memorial that people visit today. It sits along a path stretching from the US Capitol west to the Washington Monument and across the Potomac River to Robert E. Lee's pre–Civil War estate in once Confederate Virginia. This location conveys Lincoln's role as the "savior of the Union." The engravings of early-20th-century states' names around the memorial's upper regions and bas-reliefs of native plants and use of stone from both Northern and Southern states celebrate the reunification of the previously warring regions of the country. The statue of a calm and wise Lincoln sitting between engravings of his two most important presidential speeches—both of which do reference Lincoln's opposition to slavery—conveys his personality and vision.

Building the memorial was a long and complicated endeavor. Its location on a swampy former riverbed required building foundational pillars into the deep bedrock below. Workers in Colorado quarried and carved stones for the building's columns, which then were shipped by rail to the worksite, where other workers hoisted them into position and assembled them. Still others quarried, cut, and placed into position marble for the floors, walls, and interior columns. Engravers carved state names and the two Lincoln addresses, plus ornamental decorations, on different surfaces. Sculptors created the marble statue of Lincoln in sections, which were then transported to the site and assembled. Finally, the area surrounding the memorial was built out, including reflecting pools, roads, a bridge, pathways, and landscaping.

Over its century of existence, different people with varying agendas have appropriated the Lincoln Memorial for their own purposes, deploying it to suggest that, if Abraham Lincoln had been alive in their time, he would have endorsed whatever causes they promote. This began with the memorial's dedication in 1922, which focused on those aspects of Lincoln's record the designers wished to emphasize, and in which remarks about the nation's civil rights record by the day's only Black speaker were watered down and then challenged by a subsequent speaker. In the following decades, leaders of the civil rights movement sought to increase the moral power of their demands by holding rallies at the memorial, implicitly arguing that Lincoln would support their cause. Activists from other movements, such as protesting war and demanding greater economic equality, likewise sought to legitimize their positions by holding events at the Lincoln Memorial to invoke his name and values. US presidents often seek to enhance their prestige and legitimacy by participating in formal events at the Lincoln Memorial.

Given its role as a national symbol, the Lincoln Memorial has appeared frequently in popular culture—a setting for countless film and television scenes. It is featured on stamps, coins, and all manner of other objects. It is the backdrop for a wide range of activities, from advertisements to formal and informal recreational events. But most of all, it is a "must see" attraction, with millions of individuals visiting it each year in their own ways and for their own reasons.

Read on to learn more about it.

One

ABRAHAM LINCOLN

Born in a Kentucky log cabin to illiterate parents and despite less than one year of formal education, Abraham Lincoln, against all odds, transformed himself into an Illinois lawyer, state legislator, one-term congressman, unsuccessful Senate candidate, and, in 1861, president of the United States. Eleven Southern states responded to Lincoln's election by seceding from the Union, seeking to protect their power to preserve and extend a slave system that was both fundamental to their economy and protected by federal law. Lincoln's presidency was consumed by a civil war that lasted longer—and caused more injury and death—than either side anticipated.

Under pressure from abolitionists, Lincoln took advantage of eventual military successes to issue a military proclamation that made it legal for enslaved people in Confederate-controlled states to self-emancipate and find their way behind Union lines. Near the end of the war, Lincoln obtained passage of a constitutional amendment permanently ending slavery across the nation.

One month into his second term as president, Lincoln's generals obtained the surrender of rebel armies across several fronts. He then began planning to "bind up the nation's wounds" from the war, while proposing to extend voting rights to some Black Americans. In reaction to this agenda, a radicalized Confederate sympathizer and white supremacist who hoped to encourage a last-minute insurrection against the Union assassinated Lincoln while he watched a performance at Ford's Theatre. Murdered on Good Friday, Lincoln quickly became viewed as a martyr for the cause of unifying the nation and pushing it to become a more perfect Union.

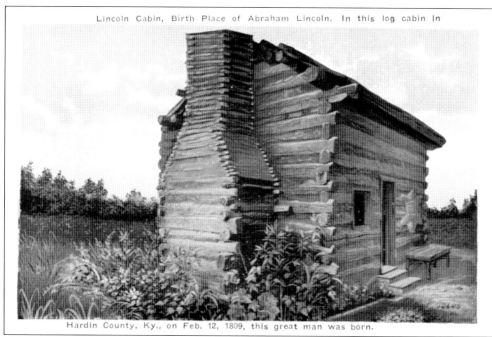
Lincoln Cabin, Birth Place of Abraham Lincoln. In this log cabin in Hardin County, Ky., on Feb. 12, 1809, this great man was born.

Abraham Lincoln was born February 12, 1809, in a Kentucky log cabin. In 1816, the family moved to Indiana, where his mother died two years later. Lincoln's father remarried in 1819, and the boy grew close to his stepmother. In 1830, the family settled on a farm on the Sangamon River in central Illinois, where the 21-year-old helped his father build their log cabin. Lincoln left home the following year, moving to New Salem, a small community in central Illinois. For a time, he worked on flatboats transporting goods down the Mississippi River to New Orleans, where he was first exposed to the atrocities of slavery. Almost entirely self-educated, Lincoln spent time in New Salem studying law and became a lawyer in 1836. (Both, LOC.)

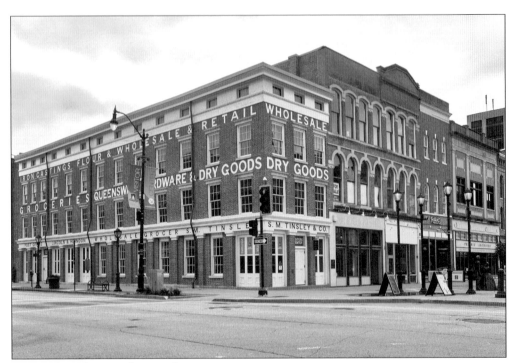

In 1837, Lincoln moved to nearby Springfield, the capital of Illinois, to practice law. He handled an array of matters, spending almost half his time traveling around the state for trials. From 1843 to around 1852, Lincoln and two partners rented an office on the third floor of this downtown building, a portion of which has been restored to its mid-19th century look and is open for public visits. (LOC.)

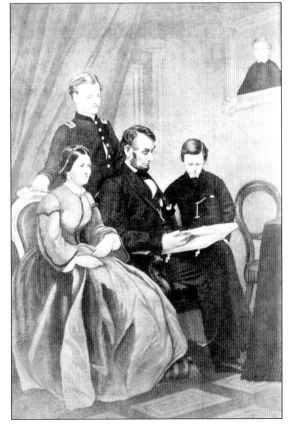

Lincoln met Mary Todd in 1839. They married in 1842 and had four sons. The oldest, Robert, lived to adulthood. The second, Eddie, died in 1850. The third, Willie, died in 1862 (the only presidential child to die while living in the White House). Willie's death forced Lincoln to balance his personal grief with continuing his duties as a wartime president. The youngest, Tad, died in 1871. (LOC.)

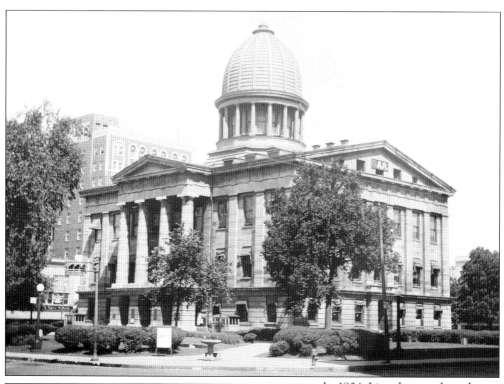

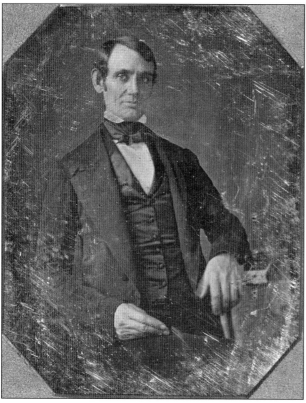

In 1834, Lincoln was elected to the Illinois House of Representatives, where he served until 1842. Shown above is the Old State House in Springfield, where Lincoln concluded his tenure in state office and later would lie in state before his burial and where then Sen. Barack Obama announced his candidacy for president in 2007. Lincoln won election to the US House of Representatives in 1846 as a member of the Whig party. Having agreed to serve only one term in order to let other local Whig candidates rotate through Congress, Lincoln did not run for reelection and left office in 1849. At left is the earliest known photograph of Lincoln, taken while he was a congressman-elect. (Both, LOC.)

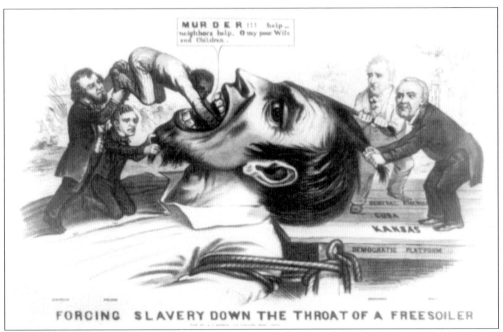

FORCING SLAVERY DOWN THE THROAT OF A FREESOILER

Lincoln opposed the 1854 Kansas-Nebraska Act sponsored by Illinois senator Stephen A. Douglas, which allowed the citizens of each newly admitted state to decide whether to allow slavery. In 1858, Lincoln challenged Douglas's reelection, running as a member of the new Republican party. Accepting his party's nomination, Lincoln declared "[a] house divided against itself cannot stand. I believe this government cannot endure, permanently half slave and half free . . . It will become all one thing, or all the other." The campaign featured seven debates between Douglas and Lincoln focused mainly on slavery. Although Douglas defeated Lincoln in the Senate election, their debates vaulted Lincoln to national prominence as a leading voice opposing slavery and a potential 1860 presidential candidate. (Above, LOC; below, KS.)

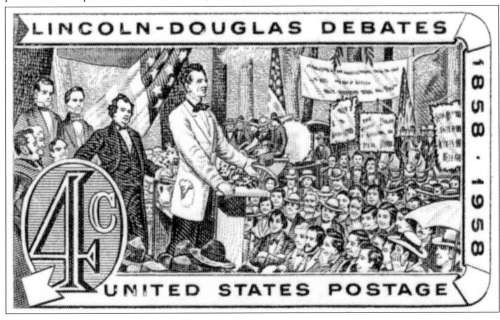

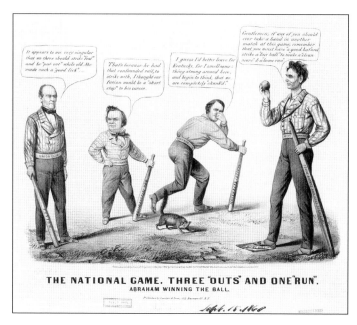

THE NATIONAL GAME. THREE "OUTS" AND ONE "RUN".
ABRAHAM WINNING THE BALL.

Relying on his image as a plainspoken, honest "Rail-Splitter" who opposed the expansion of slavery into the West, Lincoln won the Republican nomination as a dark horse candidate for president in 1860. In November, he defeated Democratic presidential nominee Sen. Stephen A. Douglas and two other candidates. Lincoln carried the "free" states in the North and far West. Shown here is a pro-Lincoln cartoon analogizing the election contest to a baseball game. (LOC.)

Soon after Lincoln's election, states in the deep South began seceding from the Union, fearing his policies against expanding slavery. In his March 1861 inaugural address, Lincoln observed that "[o]ne section of our country believes slavery is right and ought to be extended, while the other believes it is wrong and ought not to be extended." He nevertheless urged national reconciliation, declaring, "We are not enemies, but friends." (LOC.)

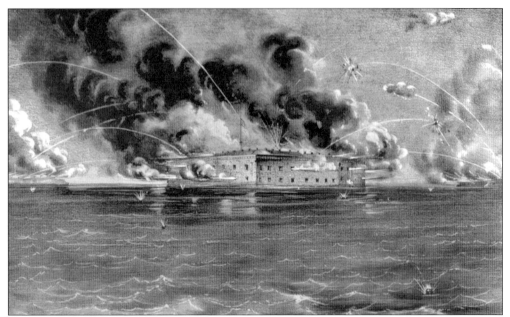

On April 12, 1861, rebel forces attacked US Army troops attempting to resupply Fort Sumter near Charleston, South Carolina. Lincoln responded by enlisting volunteers to fight in different regions of the country to restore the Union. At this early point in his presidency, Lincoln felt he lacked sufficient political support to make the war about anything but preserving the Union. (LOC.)

In 1862, Lincoln concluded that the need to recruit Black soldiers and strengthen international support for the Union required making the war's objective include ending slavery. The Battle of Antietam, in which US forces drove the rebel army out of Maryland, created political room for Lincoln to announce that, on January 1, 1863, all slaves in states in rebellion and not then under Union control would be free. (LOC.)

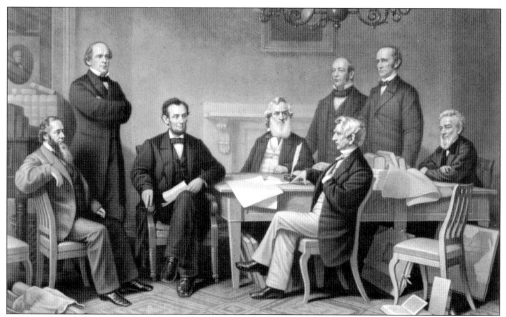

Although limited in its practical effect, the Emancipation Proclamation turned the war into a moral crusade and encouraged hundreds of thousands of slaves to escape, thereby depriving the Confederacy of manpower and bringing almost 200,000 Black soldiers into the US Army. Lincoln, depicted here with his cabinet, declared, "I never, in my life, felt more certain that I was doing right, than I do in signing this paper." (LOC.)

In November 1863, Lincoln spoke at the dedication of Gettysburg's military cemetery. In his brief remarks, Lincoln reminded listeners that the Declaration of Independence had dedicated the United States "to the proposition that all men are created equal," and that soldiers were now fighting and dying in a war that sought to bring about "a new birth of freedom" for those who had been deprived of it. (LOC.)

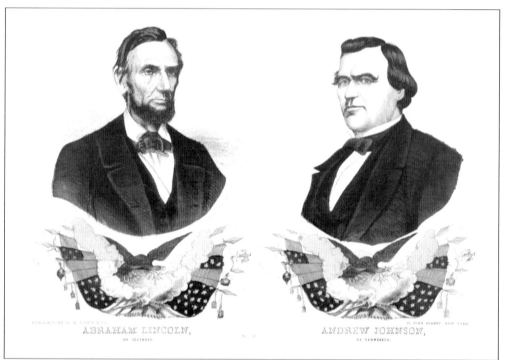

ABRAHAM LINCOLN,
OF ILLINOIS.

ANDREW JOHNSON,
OF TENNESSEE.

In 1864, Lincoln appointed Lt. Gen. Ulysses S. Grant to lead a campaign to capture the Confederate capital at Richmond, Virginia, and defeat rebel general Robert E. Lee's army. Lincoln simultaneously ran for reelection with Tennessee unionist Andrew Johnson as his vice president. Union victories before the election and arrangements to assist soldiers in voting helped Lincoln defeat Democratic nominee Maj. Gen. George McClellan (whom he had previously fired). (LOC.)

FREEDOM FOR ALL, BOTH BLACK AND WHITE!

After his reelection, Lincoln increased pressure on Congress to amend the Constitution to permanently abolish slavery. On January 31, 1865, Congress passed the Thirteenth Amendment, which prohibited "involuntary servitude" (except as punishment for a crime) throughout the United States and its territories. It took 10 months for a sufficient number of states to ratify the amendment. (LOC.)

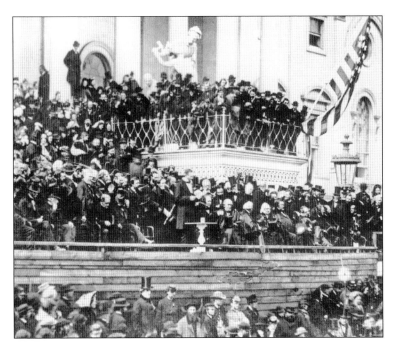

On March 4, 1865, Lincoln delivered his second inaugural address. In it, he declared that the nation's legacy of slavery was the cause of the war, suggested that the death and destruction suffered by both sides were God's punishment to the nation for permitting slavery, and called upon all Americans to "finish the work we are in," "bind up the nation's wounds," and pursue "a lasting peace." (LOC.)

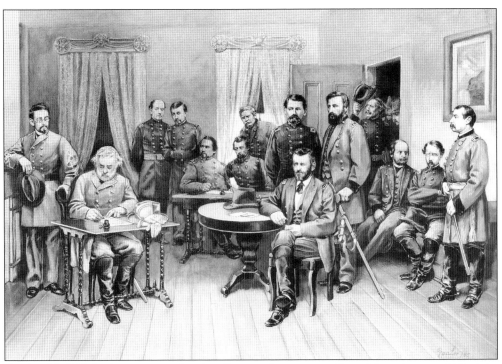

On April 9, 1865, Lee's army surrendered to Grant at Appomattox Court House in central Virginia, effectively ending the war. Grant offered Lee generous terms pursuant to Lincoln's desire to rebuild the nation. Lincoln announced a Reconstruction plan involving short-term military control of the seceded states pending their readmission to the Union. He also publicly supported extending voting rights to soldiers and other "very intelligent" Black people. (LOC.)

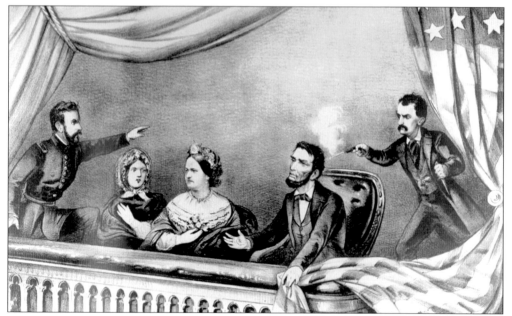

After hearing Lincoln's remarks advocating voting rights for some Black citizens, actor and white supremacist John Wilkes Booth decided to assassinate the president, the vice president, and the secretary of state to decapitate the Union's political leadership and give the Confederacy a last chance at survival. While Lincoln attended a play at Ford's Theatre on April 14, Booth entered Lincoln's box and shot him. Lincoln died the next morning. (LOC.)

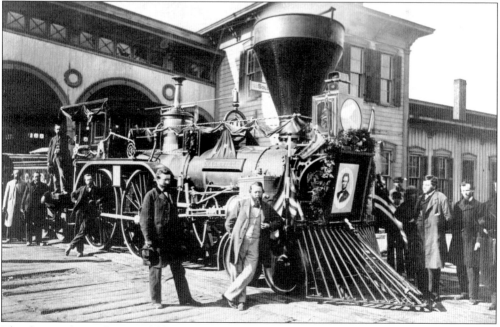

The deceased president would lie in state in the East Room of the White House and then the Capitol rotunda from April 19 to 21. The coffin containing Lincoln's body traveled for three weeks on the Lincoln Special funeral train, shown here. It followed a circuitous route from Washington, DC, to Springfield, Illinois, where the coffin was placed in a temporary vault. (LOC.)

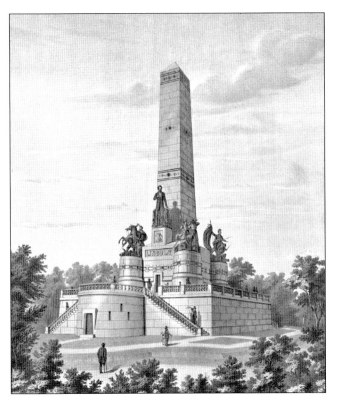

In 1874, Lincoln's coffin was moved to a permanent tomb in Springfield that also housed the bodies of his three deceased sons (Tad having died in 1871) with space for his still-living widow and son Robert. Crowned with a 98-foot-tall obelisk, the tomb included a two-ton statue of Lincoln holding the Emancipation Proclamation. Remarks at the dedication ceremony focused on Lincoln's success in ending the "stain" of slavery. (LOC.)

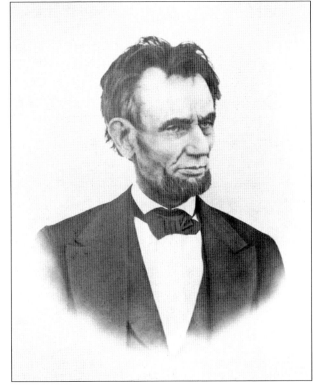

Scholars who rank presidents usually list Lincoln, George Washington, and Franklin Delano Roosevelt among the top three, although the order varies (with Lincoln usually ranked first). Lincoln has been honored in many ways across the land, including on US currency and in the names of many cities and counties. This is the last photograph of Lincoln, taken on March 6, 1865. (LOC.)

Two

DESIGNING THE MEMORIAL

Nearly 20 years before Abraham Lincoln was born, the country's first president, George Washington, decided that the fledgling government of the United States would be located in a 100-square-mile zone encompassing sections of Maryland and Virginia, where the Potomac River ceased to be navigable. That choice reflected an early legislative compromise between the Northern and Southern states in which establishment of a national bank was traded for locating the capital in a region friendly to slave-holding agricultural interests. This theme of compromising differing interests to achieve national unity would resurface after the Civil War and symbolize the memorial eventually built to Lincoln.

Washington the city and Lincoln the man both grew to maturity in the first half of the 19th century, converging in 1861 when Lincoln was elected president and moved to the capital. In 1867—two years after John Wilkes Booth assassinated Lincoln—Congress began what would be a decades-long push to memorialize the slain president with a national memorial in the capital, as was then being done for George Washington. But the combination of politics and continued post–Civil War regional strife stalled any progress.

In 1901, Congress formed the Senate Park Commission, commonly called the McMillan Commission, to reshape the look of the capital. This included monuments and a central grand avenue, as originally conceived by the city's planner, Pierre L'Enfant. A memorial to Lincoln would sit at the western terminus of what became known as the National Mall.

The 20 years it took to design and construct the memorial coincided with the height of the Jim Crow era, in which early post–Civil War efforts by Republican political leaders to grant Black citizens the same rights as White citizens ebbed. In this political and social climate, those who had the most influence over the design and characterization of a memorial to Abraham Lincoln were motivated to deemphasize Lincoln's opposition to, and successful effort to end, slavery. Instead, they sought to use the memorial to portray Lincoln as a man from humble origins who, through his wisdom, savvy, and eloquence, saved the Union.

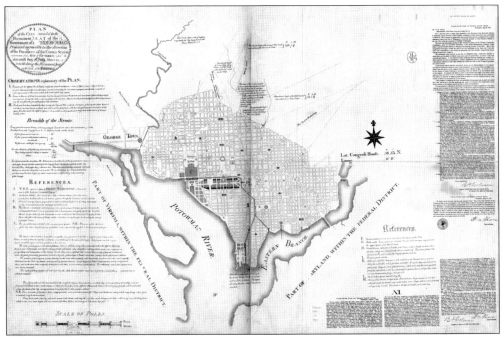

In 1791, Pres. George Washington appointed French architect Pierre L'Enfant to design the layout of the country's newly designated capital of Washington, situated on a swampy stretch of land along the Potomac and Anacostia Rivers. L'Enfant devised a grid of streets, anchored by a "grand avenue" of majestic buildings and monuments that became the National Mall. (LOC.)

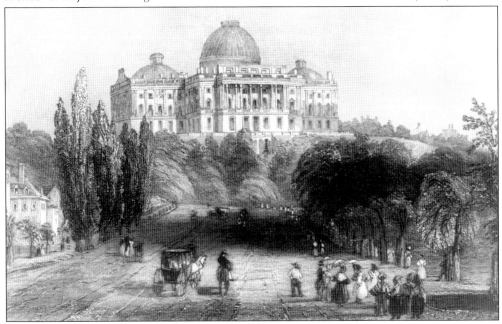

The president's house and Capitol building both opened in 1800. The latter, shown here, marked the eastern terminus of the grand mall. The other end lay 1.5 miles to the west, where the Washington Monument would later be built about one-half mile south of the president's house. The area to the west, where the Lincoln Memorial would eventually be built, was still under water. (LOC.)

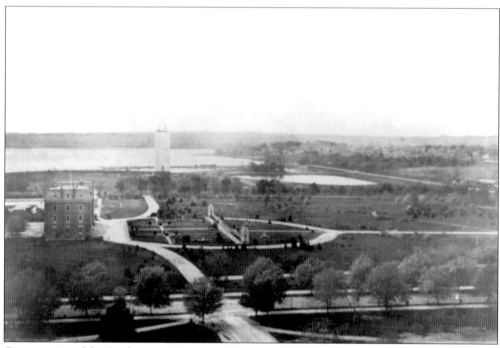

Construction of the Washington Monument began in 1848 (then Representative Lincoln attended the laying of the cornerstone ceremony). Funding issues slowed the process, and it was not completed until 1884. The structure is a 555-foot-tall hollow obelisk with interior stairs and an elevator leading to an observation deck with a 360-degree view. This 1870s image taken from the original Smithsonian Institution building shows the monument under construction. (LOC.)

After Lincoln died in 1865, he was hailed by many—particularly in Northern states—as a demigod. This image was modeled on that of George Washington, who many people also considered semidivine. The two became strongly linked, one as the founder of the nation, the other as its savior. The stage was thus set for their eventual enshrinement together at the capital for which they both fought. (LOC.)

In 1867—two years after Lincoln's death—Congress passed the first of several acts dedicated to creating a memorial to honor the 16th president (as had been done for President Washington). The intent was to commemorate Lincoln's role in bringing about "the great charter of emancipation and universal liberty in America." (LOC.)

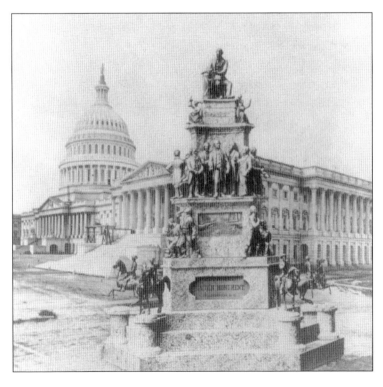

Congress established the Lincoln Monument Association in 1867 to manage the development of the memorial. The association hired sculptor Clark Mills to create a design. He envisioned an elaborate 70-foot-tall bronze structure that focused on the emancipation element of Lincoln's legacy. It featured several dozen statues on multiple tiers, topped by a 12-foot-tall statue of a seated Lincoln signing the Emancipation Proclamation. (LOC.)

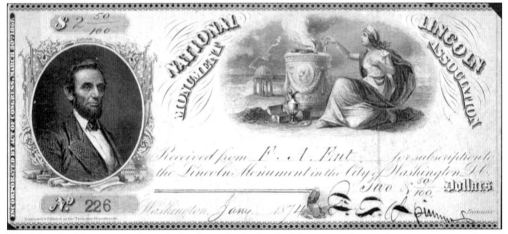

The Lincoln Monument Association launched a fundraising campaign to finance construction of the memorial through private subscriptions. This did not come close to raising the required capital. After a decade, the effort fizzled as congressional support also waned with the Republicans losing their majority in Congress and thus lacking the power to keep the idea moving forward. (LOC.)

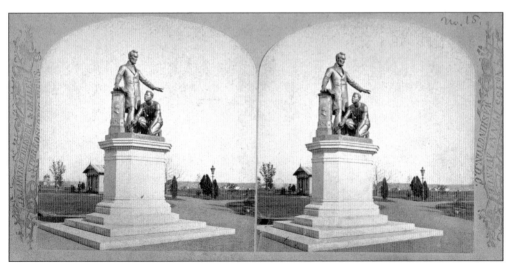

While the Mills memorial did not proceed much past the planning stage, the idea behind it was captured in the Freedmen's Memorial, designed by Thomas Ball. Dedicated by Frederick Douglass in 1876 in Lincoln Park, near the Capitol building, it depicts an enslaved man rising to his knees at Lincoln's feet. This depiction has drawn criticism as demeaning Black people by ignoring their role in freeing themselves from bondage. (LOC.)

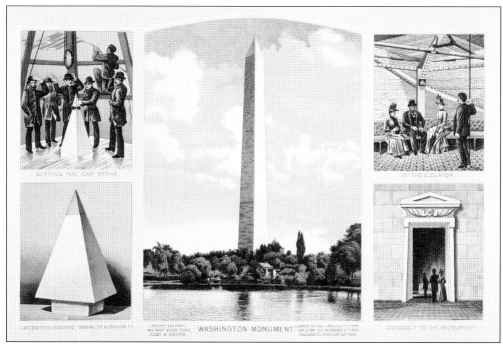

Motivation to memorialize Lincoln receded in the last quarter of the 19th century. The equally balanced Congress avoided even discussing this polarizing topic and instead looked to finish the monument to George Washington. Spurred by this congressional mandate, the Washington Monument, begun in 1848, was finally finished in 1884. (LOC.)

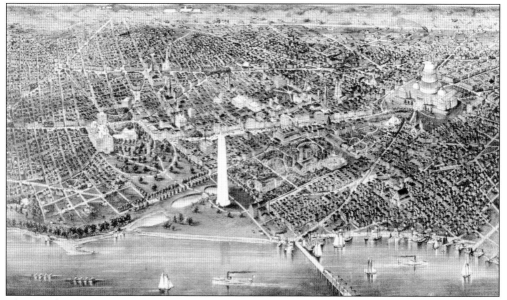

The Washington Monument stands near what was originally the tidal flats of the Potomac River. This would soon change with the Army Corps of Engineers' long-term project to dredge the river, remove silt to deepen the shipping channels, and dump the refuse along the tidal flats. This project extended the land by a mile, creating areas designated for recreation and named East and West Potomac Parks. (LOC.)

Starting around 1876, Republican-led Reconstruction efforts evolved into a focus on redemption, in which political leaders prioritized bringing Southern states fully back into the Union over securing full legal rights for Black citizens. As this happened, views about Lincoln among White people in the Southern states gradually softened, and he came to be remembered more for "saving the Union" than for ending slavery. (LOC.)

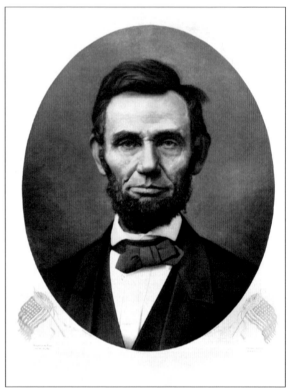

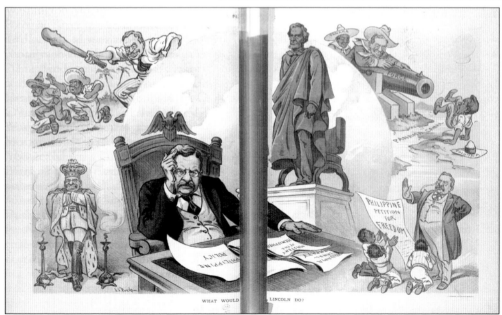

The 1896 election of William McKinley as president began a 16-year period of Republican control of the presidency and Congress. Spurred by a vigorous economy and victory in the Spanish-American War, national pride and unity skyrocketed. Republicans promoted Lincoln—the first GOP president—as a hero, a perspective that Lincoln's former opponents now embraced. From this adulation grew the guiding mantra, "What would Lincoln do?" (LOC.)

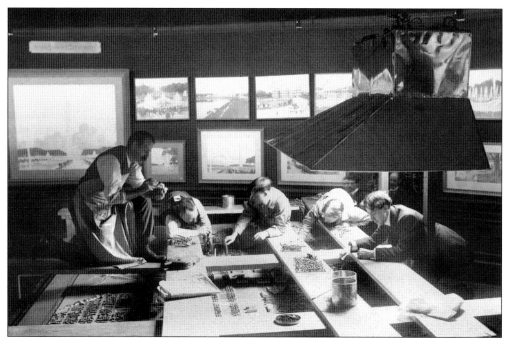

The reshaping of the capital and the reinterpretation of Lincoln merged in 1901 with the formation of the Senate Park Commission (McMillan Commission). Created in honor of the 1900 centennial of establishing the national capital in Washington, DC, the commission sought to redesign the National Mall and surrounding park area and include a shrine to Lincoln. Here, several men work on a model of the resulting McMillan Plan. (LOC.)

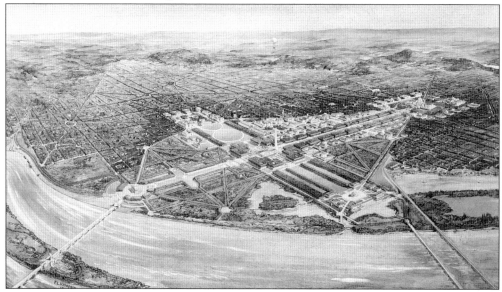

While certain elements of Pierre L'Enfant's 1791 plan for Washington were implemented, many others were ignored. Over the years, the area became festooned with slums and farms. The McMillan Plan harkened back to L'Enfant's central ideas, planning to turn these run-down areas into landscaped lawns and treed walkways, punctuated by Neoclassical buildings and centered around a National Mall. (LOC.)

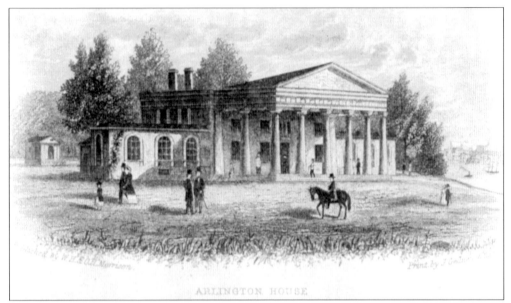

ARLINGTON HOUSE

The commission considered locating the Lincoln Memorial in other places, but it ultimately decided on the western terminus of the National Mall to align it with the Capitol building and the Washington Monument. It also aligned with Arlington House, the former home of Robert E. Lee in Arlington National Cemetery, the country's most celebrated military cemetery. (LOC.)

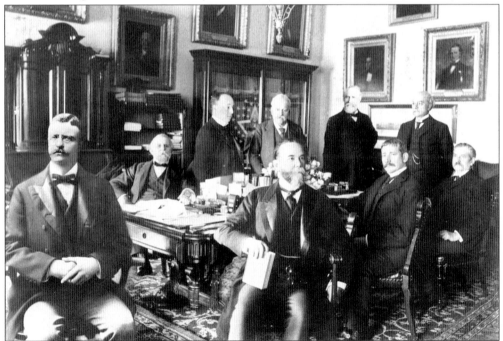

Pres. Theodore Roosevelt and his cabinet, shown here, enthusiastically supported the McMillan Plan because its proposed grandeur fit their vision of the United States with its strong federal government and emerging status as a world power. The plan especially resonated with Roosevelt—whose hero was Lincoln—and Secretary of State John Hay, who nearly four decades before had served as Lincoln's assistant private secretary. (LOC.)

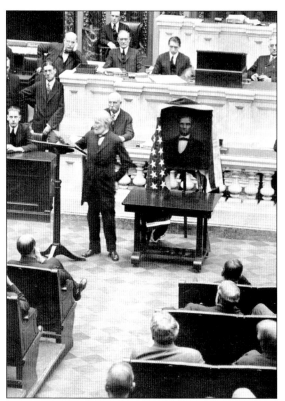

As strongly as Roosevelt and his team supported the McMillan Plan, Speaker of the House Joe Cannon, shown here reading the Gettysburg Address, opposed it. He was unhappy that it was developed without involvement from the House and hated the location "in that God damned swamp." Although Cannon was a Republican like Roosevelt, he opposed the president on many issues, including the memorial. (LOC.)

Joe Cannon's opposition to the memorial slowed its development for years. But when the 1909 centennial of Lincoln's birth drew near, public pressure to celebrate him increased. In Kentucky, the Abraham Lincoln Birthplace National Historical Park was developed. It featured a reconstructed cabin similar to the one in which Lincoln was born, enclosed within a Neoclassical Greek temple designed by architect John Russell Pope. (LOC.)

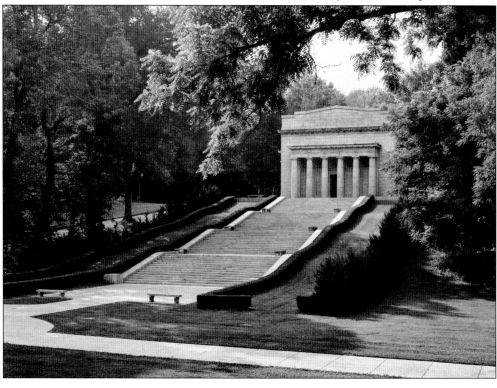

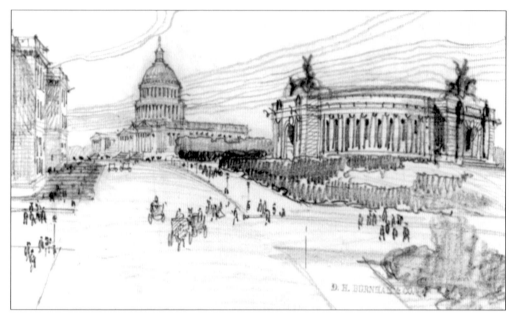

By 1908, three proposals for a national Lincoln memorial were under active consideration: a memorial at Potomac Park, as described in the McMillan Plan; a proposed "Lincoln Road," consisting of a landscaped parkway from Gettysburg to Washington, DC; and expansion of the Capitol grounds that would include a statue of Lincoln near Union Station, as depicted here. (Architect of the Capitol.)

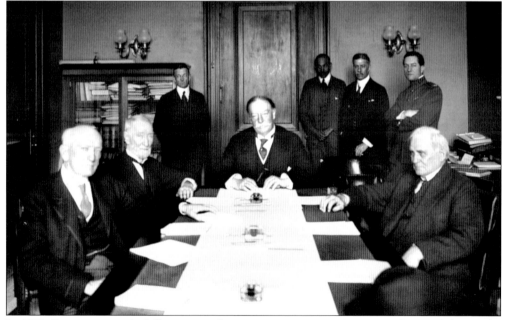

In 1911, Congress passed a bill creating a bipartisan commission "to secure plans and designs for a monument or memorial to the memory of Abraham Lincoln." Despite Joe Cannon's presence, the commission as a group supported the McMillan Plan. Furthermore, Pres. William Howard Taft served on the commission, so the plan finally seemed on track toward construction of a memorial. (LOC.)

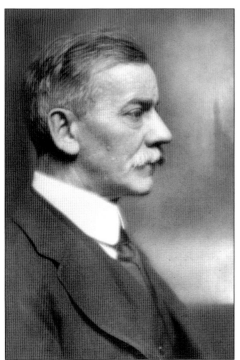

The Lincoln Memorial Commission worked in close consultation with the Commission of Fine Arts. One of its first acts was to designate Henry Bacon as consulting architect. Bacon was of the Beaux-Arts school and in the early 1890s had represented the architecture firm of McKim, Mead & White at the World's Columbian Exposition in Chicago, for which the group had designed several buildings. (LOC.)

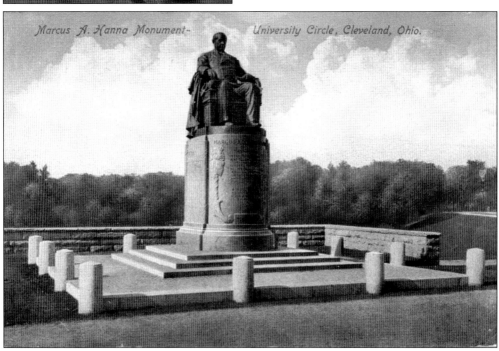

Several years before Henry Bacon began working with the Lincoln Memorial Commission, he had designed both a mausoleum and monument for wealthy Ohio businessman and politician Marcus Hanna. The mausoleum is at Lakeview Cemetery in Cleveland, Ohio, and the monument, shown here, sits less than two miles away. William Howard Taft, then serving as secretary of war, attended the 1908 monument dedication. (KS.)

Henry Bacon initially was to serve simply as an advisor, but the commission ignored the typical practice of holding a design competition and soon asked Bacon alone to submit proposals for a Lincoln memorial on the Potomac River. Joe Cannon was still against this location and maneuvered to invite a second architect, John Russell Pope (shown here), who had designed the Abraham Lincoln Birthplace National Historical Park building, to also submit designs. (LOC.)

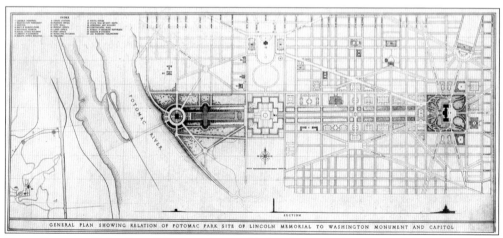

GENERAL PLAN SHOWING RELATION OF POTOMAC PARK SITE OF LINCOLN MEMORIAL TO WASHINGTON MONUMENT AND CAPITOL

Henry Bacon and John Russell Pope each assembled and presented a variety of plans. This played out in a two-stage process with each submitting an initial set of drawings in 1911 and then a revised set in 1912. Bacon's design followed the McMillan Plan's suggested location in Potomac Park, on the shores of the Potomac River at the west end of the National Mall. (WU.)

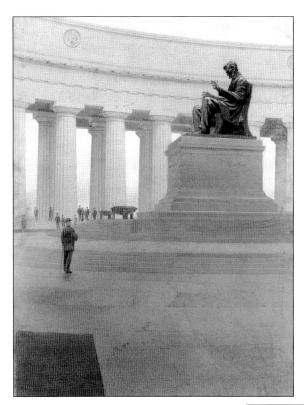

John Russell Pope's preferred site, which Joe Cannon also favored, was at the Soldiers' Home. Located on a hill four miles north of the Capitol building, this shelter for Civil War veterans has a sweeping view of Washington, a feature that the commissioners prized. In this rendering of Pope's Soldiers' Home design, a statue of a seated Lincoln sits atop a pedestal in the center of the building. (NA.)

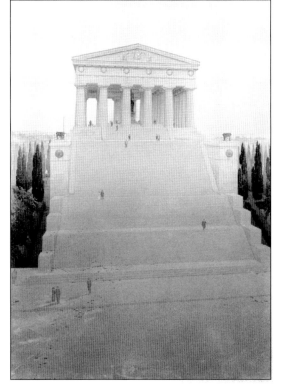

John Russell Pope also created drawings for a site on Meridian Hill, so named because it is 1.5 miles north of the White House and used to establish the so-called White House Meridian—one of four lines of longitude once recognized as a prime meridian for the United States. Here, Pope proposed to build an elevated Greek-like temple with a statue of a seated Lincoln inside. (NA.)

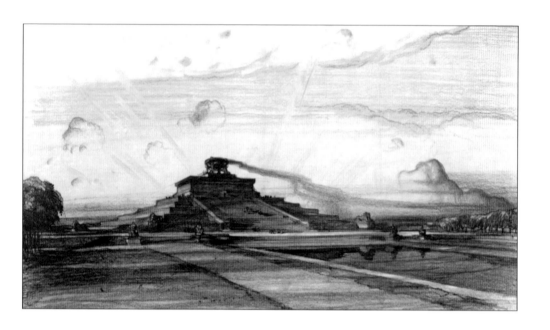

In addition to his classical designs, Pope produced a number of other drawings featuring more idiosyncratic structures. This seemed an exercise more in artistic creativity than in serious design, as none of the schemes were practical, and Pope admitted that he did not care for them. He borrowed designs from different ancient cultures and sketched adaptations of them in graphite. Each included pools of water on at least one side. One (above) featured a stepped, Mayan-type pyramid like those built in Central America in the first millennium. Another pyramid design (below) included a four-sided Egyptian-style structure based on those built several thousand years ago in northern Africa. It included portico entrances on each side. (Both, NA.)

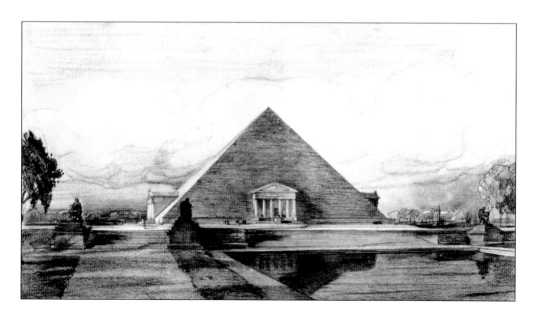

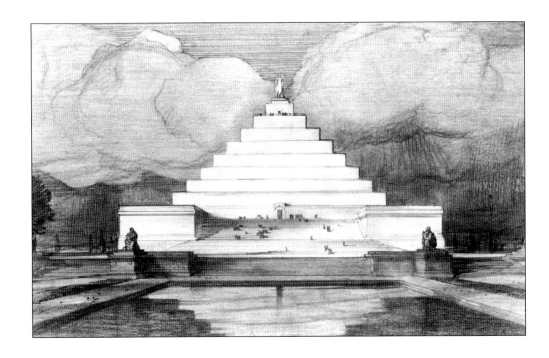

John Russell Pope featured ziggurats in two more of his impractical yet imaginative designs. These harken back to massive structures built in ancient Mesopotamia before the Egyptian pyramids and indeed may have inspired those later structures. Historians believe they may have served as some sort of shrine and may also include elements with astrological significance. Pope designed two variations of a ziggurat. The first (above) featured dramatic terraces leading to a top level crowned with a statue of Lincoln. The second (below) was circular with subtler terraces but still had a statue at the top. While this set of designs drew the attention of curious onlookers, they were never seriously considered for the memorial to Lincoln. (Both, NA.)

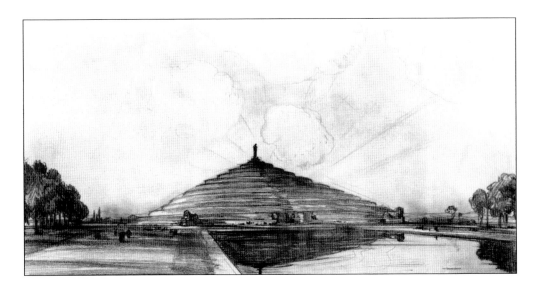

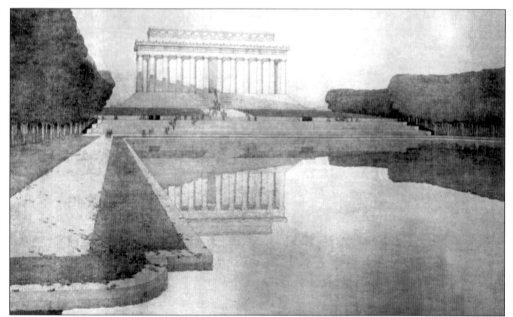

This early vision of Henry Bacon's is similar to his final design. The structure is placed on a raised terrace with several levels of steps leading down to an elongated "large lagoon" bordered with walkways on either side. One difference is that Bacon originally planned for doors that would lead into the middle chamber. He later dismissed this idea, leaving the chamber open to the outside. (WU.)

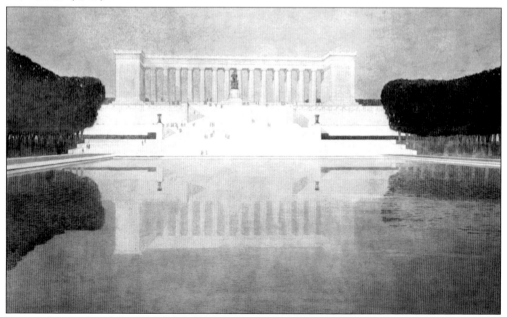

Bacon also explored the possibility of a more open-air design, creating a series of drawings in which he tried different arrangements of colonnades, tablets, and statues. He ultimately stuck with his original idea of a more closed design, largely because this would allow the statue to be viewed in consistent lighting (an open-air design could introduce constantly changing sunlight hitting the statue). (WU.)

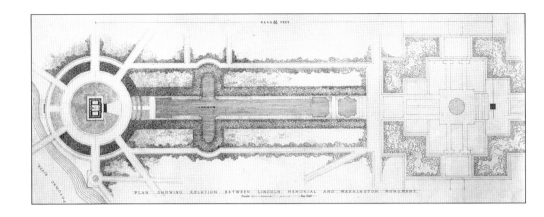

PLAN SHOWING RELATION BETWEEN LINCOLN MEMORIAL AND WASHINGTON MONUMENT

The commission selected the Potomac Park site on February 3, 1912. The following month, it reviewed the revised designs from Henry Bacon and John Russell Pope. On April 12, the commission essentially chose Bacon's plan when it asked him to submit a final design. Bacon did so on June 28, and on December 4, the group officially adopted the design. Congress approved the plans on January 29, 1913, and a month later, the commission officially selected Bacon as the architect. While he continued to tweak his design through the production phase, the basic parameters stayed the same. The memorial would be located at the western end of the National Mall and be encircled by a system of roads radiating out (above). The semi open-air building would sit atop a terrace and be reached by a series of flights of steps (below). (Both, WU.)

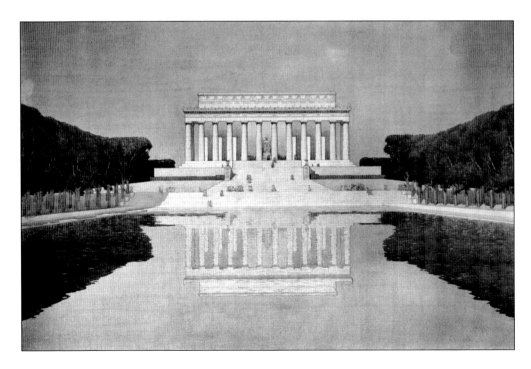

Three

BUILDING THE MEMORIAL

The Lincoln Memorial Commission, formed in 1911 and including Pres. William Howard Taft, designated architect Henry Bacon to direct construction of the Lincoln Memorial. This was only natural, as Bacon had submitted the winning design. He would go on to modify many characteristics of the structure over the subsequent years of design and construction. Among other things, he thickened the exterior columns to give them a sturdier appearance and, working with sculptor Daniel Chester French, nearly doubled the height of the Lincoln statue from 10 to 19 feet so it would not be dwarfed inside the expansive building.

As discussed earlier, much of the planning of the memorial touched on the theme of national unity, and this continued during construction. For example, building stones came from a variety of states across the nation. Both Northern and Southern states were represented, with marble and granite from Colorado, Tennessee, Indiana, Alabama, Georgia, and North Carolina being used for different aspects of the building, statue, reflecting pool, and surrounding landscape.

From the beginning of construction in 1914, work progressed sporadically as many challenges arose. For instance, the unstable ground required workers to anchor the subfoundation dozens of feet down to the bedrock. Poor winter weather also halted construction, as did the need for the country to focus efforts and resources on World War I. When the memorial opened eight years later in 1922, the reflecting pools and many other related features remained unfinished.

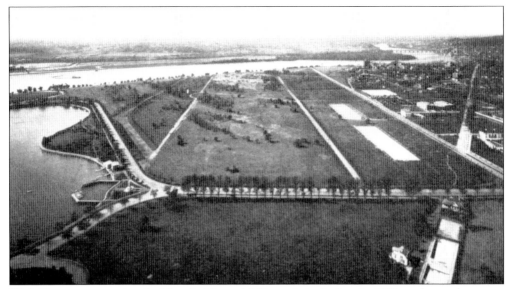

With Congress approving the Lincoln Memorial Commission's plans in 1913, work soon began on the actual construction of the memorial. One of the first steps, prior to any construction, was to test the integrity of the ground where the large and heavy memorial would sit (shown here). This involved taking core samples through the 40–60 feet of marshy sand and gravel to bedrock. (KS.)

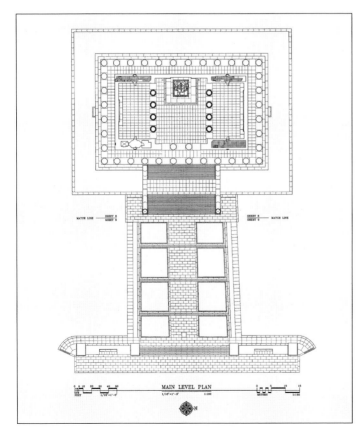

MAIN LEVEL PLAN

Henry Bacon revised his design in 1913 and continued tinkering with it over the ensuing years. Here is the final rendering of the memorial, as drawn in 1993 from a report of the Historic American Buildings Survey, a National Park Service program that documents historic places in the United States. (LOC.)

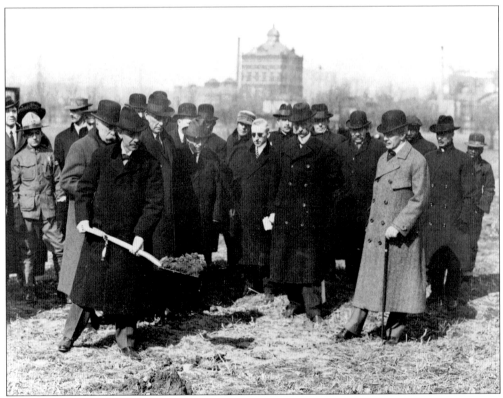

On February 12, 1914—the 105th anniversary of Lincoln's birth and nearly 49 years since his assassination—a small group of memorial planners, contractors, and government officials gathered at the northeast corner of the site for a modest groundbreaking ceremony. Above, Henry Bacon turns a shovelful of dirt. Kentucky senator Joseph Blackburn, directly to the left of Bacon, briefly spoke about how the memorial was meant to represent the reunification of the nation. Just a week prior to the ceremony, Blackburn (at right, earlier in his life) had assumed the role of special resident commissioner of the Lincoln Memorial Commission. (Above, WU; right, LOC.)

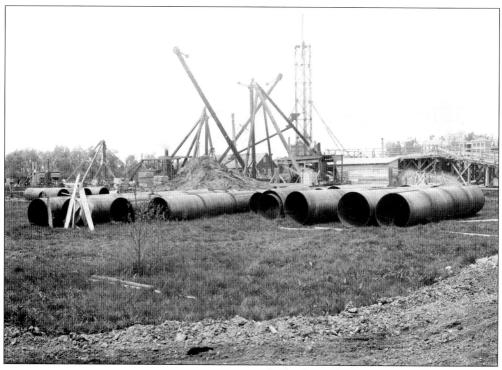

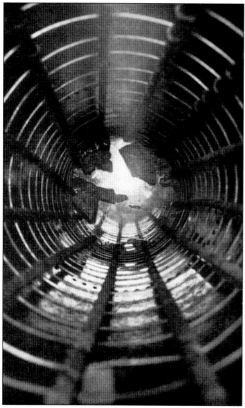

The land on which the memorial would sit—with its dozen feet of dredged fill on top of soft layers of sand and loose rock—was not solid enough to support a massive structure. Engineers thus devised a two-part foundation. The lower, subfoundation included 122 concrete piers formed in hollow steel cylinders extending down to the bedrock. The cylinders ranged in diameter from 3.5 feet to 4 feet, 2 inches, and were 20 feet long. Several of them were attached end to end to reach down into the bedrock—some 49–65 feet in length. The above picture shows several of the cylinders lying on the ground, ready for use. The picture at left shows the interior of one of the cylinders with a network of vertically set reinforcing rods. (Above, WU; left, KS.)

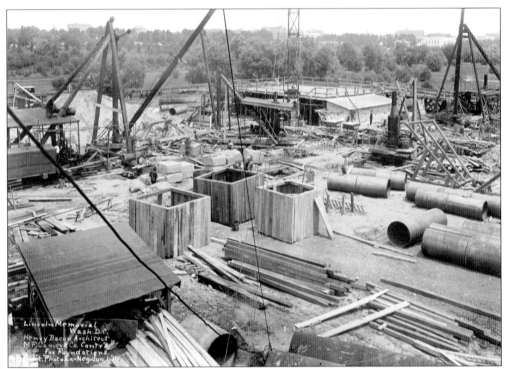

Workers created a pier by first inserting a square wooden frame (above) into holes measuring 10–12 feet deep. They then aligned a cylinder vertically inside the frame and stacked 10–20 tons of concrete blocks on top (below), which, in combination with jets of water, caused the cylinder to sink into the soft earth. Once the entire cylinder was buried, another was attached and the process repeated until the cylinders hit bedrock. The workers removed the debris inside the cylinder by hand, then used explosives to sink the shaft two more feet into the bedrock. They then poured cement into the cylinder, in many cases adding a network of reinforcing steel rods. The tops of the piers, at ground level, were connected by a one-foot-thick concrete framework, on top of which the upper foundation would sit. (Both, WU.)

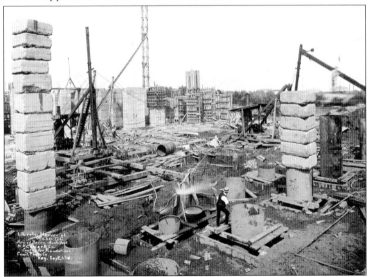

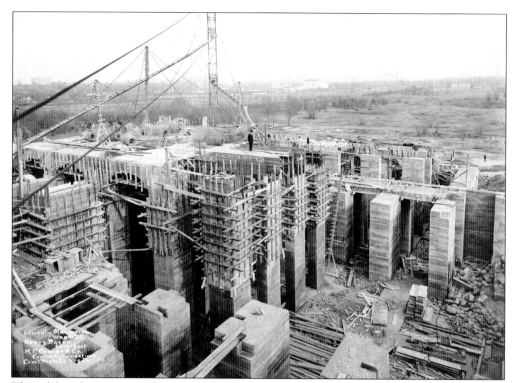

The subfoundation was finished by mid-1914, and then the upper foundation was added. This consisted of rectangular, reinforced concrete columns sitting on top of the subfoundation piers. They were connected by flat-topped, concrete arches over which the floor of the memorial would be installed. The above photograph shows these features as well as the Washington Monument at upper right. The image below shows further development of the upper foundation with the base for the platform, on top of which the floor later would be installed, coming into shape. Work on the upper foundation was completed by early spring 1915. (Both, WU.)

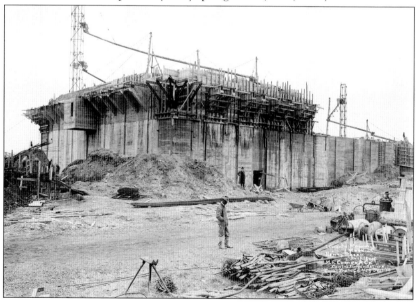

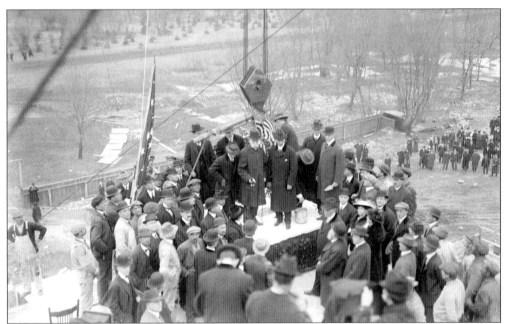

As the foundation neared completion, workers redirected their attention to the building's superstructure. On February 12, 1915—the 106th anniversary of Abraham Lincoln's birth and one year to the day after construction had begun—contractors and officials gathered to ceremonially lay the building's cornerstone. The chosen stone weighed 17 tons and measured nearly eight feet square and three feet high. It forms the base of the colonnade column at the northeast corner of the building and contains a cavity in which officials placed a box of several dozen commemorative items, including a Bible, an autograph by Lincoln, and other items of intrinsic historical value. After the cornerstone was put in place, officials made a few brief comments (above) and then an American flag was unfurled (below). (Both, LOC.)

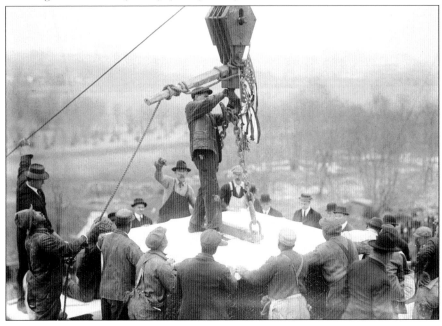

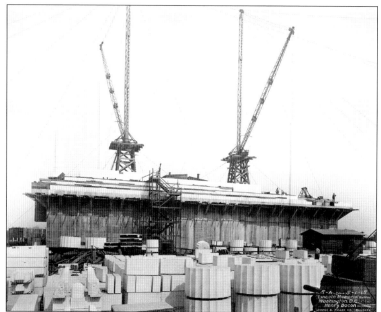

Compared to the dull gray concrete of the upper foundation, the three-stepped, lighter-colored marble platform supporting the building itself stood out as it was installed in May 1915. Once it was in place, workers began assembling the memorial's walls and columns, whose components are shown here stacked at the ready in the foreground. (WU.)

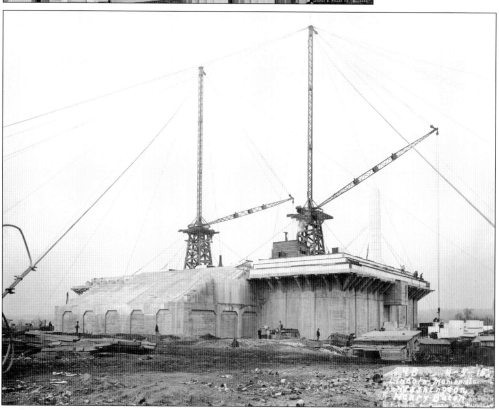

In this 1915 photograph showing the east and north sides of the structure, the upper steps and platform-topped upper foundation stand stark against the landscape. This is before the terrace and lower steps, as well as most of the building itself, was added, but one can start to visualize the familiar east-facing entry of the memorial. (WU.)

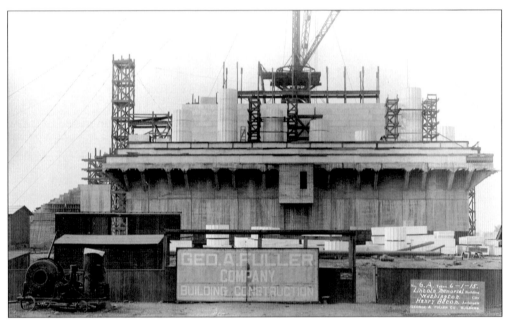

Henry Bacon contracted the George A. Fuller Company to build the superstructure. The company's founder and namesake was a prolific builder, often called the father of the modern skyscraper. Fuller died in 1900, but the company continued to prosper and built such other Washington area structures as the Tomb of the Unknown Soldier and the Memorial Amphitheater, both at nearby Arlington National Cemetery. (WU.)

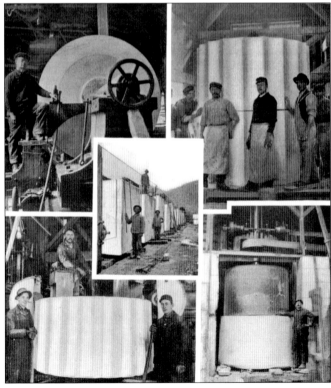

For the exterior walls and columns, Henry Bacon wanted to use an exceptionally pure rock, Yule marble, from the West Elk Mountains of Colorado. Although the cost of transporting tons of this material across the country was steep and not everyone agreed with Bacon about this choice, he persevered. This image from the March 20, 1915, edition of *Scientific American* illustrates the process of mining and preparing the rock. (KS.)

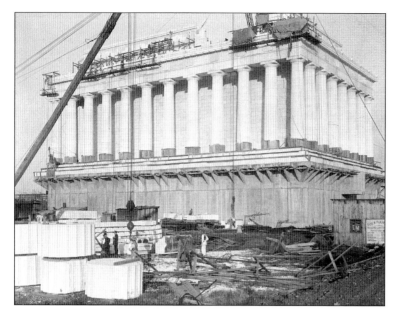

For the 36 exterior columns alone, 456 blocks of Yule marble were mined in Colorado. Each measured about 8 feet wide by 4.5 feet tall and weighed 25 tons. The blocks were sent by train several miles away to the company mill. They were trimmed, then reloaded onto a train and sent to Washington. A special spur line ran to the construction site. (LOC.)

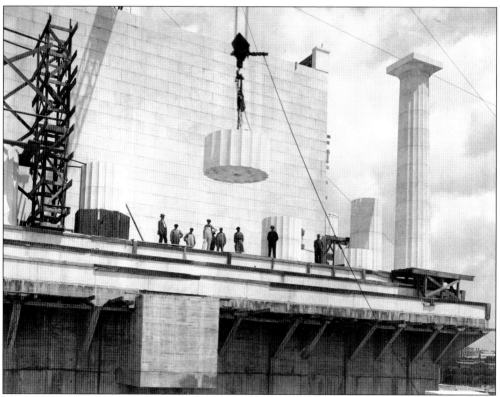

Each exterior column consists of 11 vertically stacked blocks, called drums, plus another one that serves as the capital (or capstone) of the column. These individual drums are easy to distinguish at the monument or even in pictures of it. This photograph was taken in 1916, decades before the modern employee safety practices of the Occupational Safety and Health Administration were in effect. (WU.)

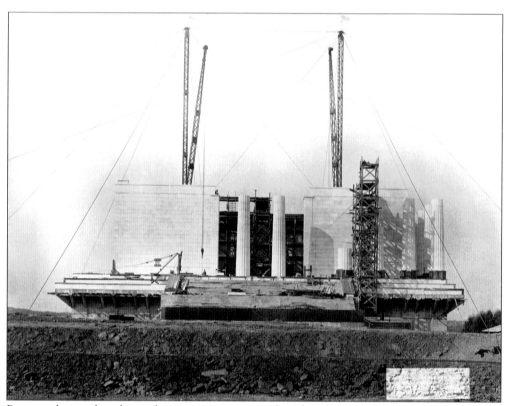

Progress during this phase of construction was rapid, with teams of workers raising the exterior walls and assembling the fluted drums into columns. Both of these photographs were taken in 1915. The one above shows a view of the east side with the upper level of steps and several freestanding columns but before the frieze, attic, and other upper components were added. Below is the west side with columns in various stages of assembly. Scaffolding allowed workers to access the columns. By mid-1916, all of the exterior walls and columns were in place, and work continued upward to the attic. (WU.)

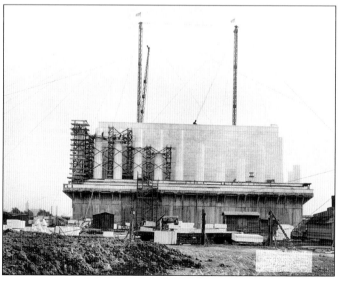

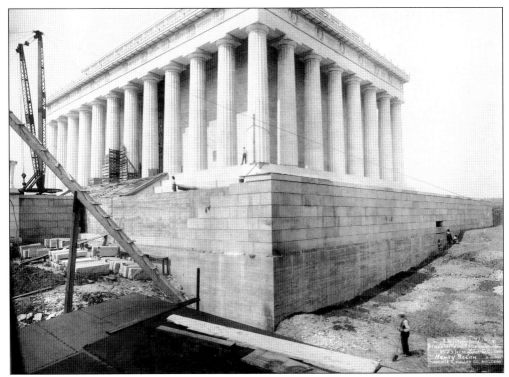

In mid-1916, work began on the area immediately surrounding the memorial. Laborers hauled in dirt to build up an earthen mound that topped off just below the three platform-like steps surrounding the structure. The mound was flattened on the top and enclosed on the sides by a granite wall, resulting in a grass-covered terrace. (WU.)

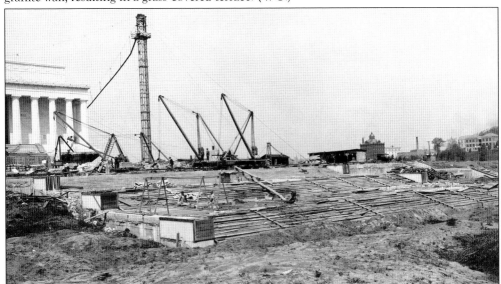

Another outdoor improvement was the installation of the lower levels of stairs, made of granite from Massachusetts. When the project was finished, there were 59 steps from the inside chamber down to the plaza level and another 28 steps to the reflecting pool—for a total of 87 steps. Some have tried to attach significance to the number of steps, but experts generally discount this. (WU.)

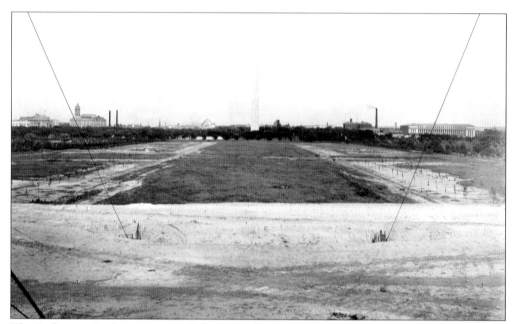

The Reflecting Pool was not installed until mid-1923—a year after the memorial opened. Until then, the rectangle of land on which it would sit, extending toward the Washington Monument, remained undeveloped. While visitors could still feel the connection between the Lincoln Memorial and Washington Monument, it was not nearly as charming as it became when the pool was later added. (WU.)

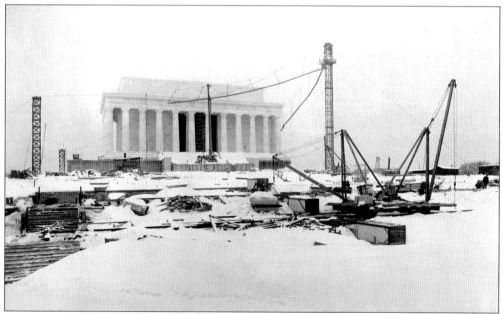

With the United States' entry into World War I in 1917, the pace of construction slowed as resources were redirected toward the war effort. Delays were exacerbated by severe weather during the winter of 1917–1918. Not until spring 1919 did the pace pick back up. Much of this renewed effort focused on interior features such as murals and the centerpiece of the memorial—a statue of Abraham Lincoln. (WU.)

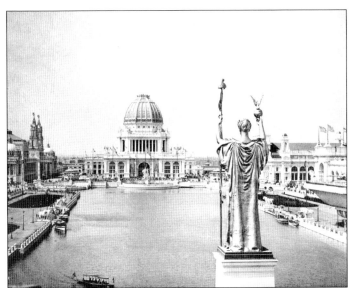

Back in 1914, ten months after groundbreaking for the memorial, Daniel Chester French had joined the Lincoln Memorial project as the man who would design the Lincoln statue. Henry Bacon pushed for French's involvement because the two had worked together in the past, most notably at the 1893 World's Columbian Exposition in Chicago. Here is French's *The Republic* statue from that event. (WU.)

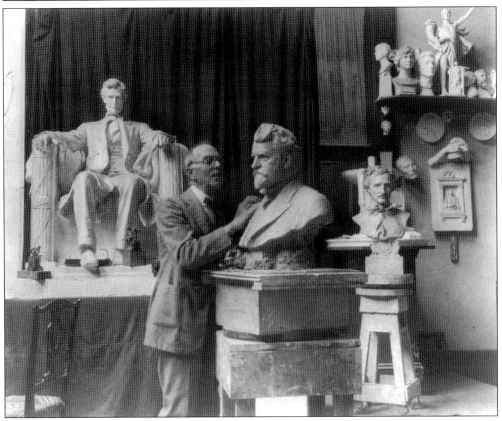

Daniel Chester French spent several years exhaustively studying Lincoln and thinking about how he would sculpt him. He created several models, including the one shown here at his Chesterwood studio in Stockbridge, Massachusetts. Based on his studies, he and Bacon realized that the vast memorial chamber would dwarf the proposed statue. They ended up nearly doubling its size, to 19 feet high, to make it fill the space. (Chapin Library, Williams College.)

In the fall of 1918, Daniel Chester French sent his final model to a family of stonecutters in New York, the Piccirilli brothers, who would carve the statue. They completed the project the following fall and then sent the massive statue, consisting of 28 blocks of Georgia marble, to Washington. Workers began installing the statue in December 1919 and finished the following month. (WU.)

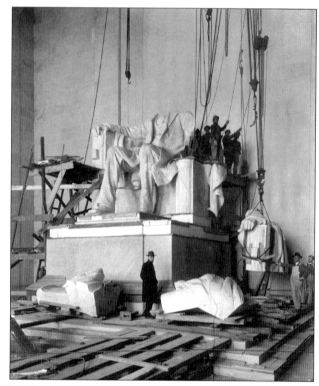

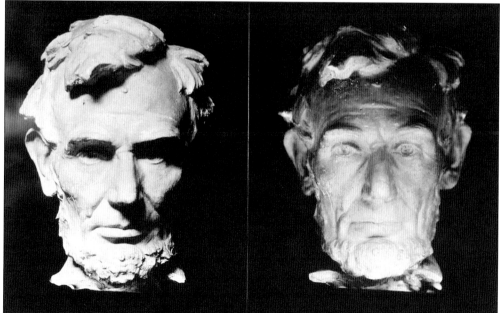

Even after the memorial opened, French felt angst about his creation. The lighting on the statue during the dedication was quite poor. French later tried to get this fixed and at one point compared a picture of a properly illuminated large model in his studio (left) to a picture of the actual statue at the memorial (right). Thanks to his efforts, proper lighting was eventually installed. (Chapin Library, Williams College.)

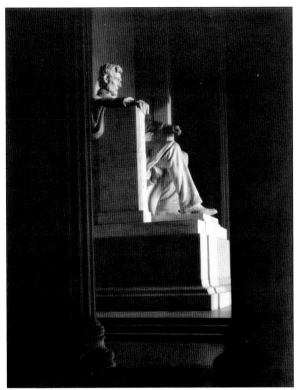

With the statue in place, officials hoped to dedicate the Lincoln Memorial soon. However, this was delayed due to sinking of the terrace's retaining wall foundations. To save money, planners had decided to rest them on floating foundations rather than run the support structure down into the bedrock, as had been done for the main building. They fixed these problems in early 1922, setting the stage for a grand opening and dedication. The final cost of the Lincoln Memorial was just over $3 million (nearly 50 million in 2021 dollars). The structure measures 202 feet in the north-south direction at the widest point and 132 feet across on the east-west axis. It is 80 feet high from main floor to roof and 192 feet from the ceiling down to bedrock. (Both, WU.)

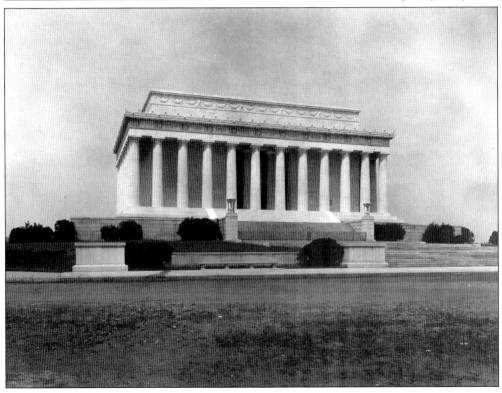

Four

THE MEMORIAL'S SURROUNDINGS

The Lincoln Memorial does not exist in a vacuum. Instead, it is one of the anchors of the National Mall and surrounding areas, which are filled with important historic structures. The Lincoln Memorial's designers deliberately located it in proximity to preexisting sites, such as the Capitol building, Ulysses S. Grant Memorial, Washington Monument, and Arlington National Cemetery (encompassing Robert E. Lee's home). This siting signaled Lincoln's important role in the historical events represented by these structures. Thereafter, designers of many new memorials to national leaders (like Franklin Delano Roosevelt and Martin Luther King Jr.) and monuments to events (like 20th-century wars) located those structures in places having a symbolic relationship to the Lincoln Memorial. In short, the Lincoln Memorial was intended to reference preexisting structures on the National Mall, while many later-built memorials and monuments were intended to reference the Lincoln Memorial.

This chapter contains a tour of important sites in the area surrounding the Lincoln Memorial in both the District of Columbia and Virginia. It begins with a discussion of structures that existed before construction of the Lincoln Memorial, explaining how the memorial relates to those places. It then describes, in roughly the order they were built, the pools, parks, memorials, and monuments that came after the Lincoln Memorial, explaining why they are located where they are and how they relate to the Lincoln Memorial. Finally, it describes the memorial's immediate surroundings, including meadows, trees, paths and roads, bridges, lighting, and visitor support facilities. Come along!

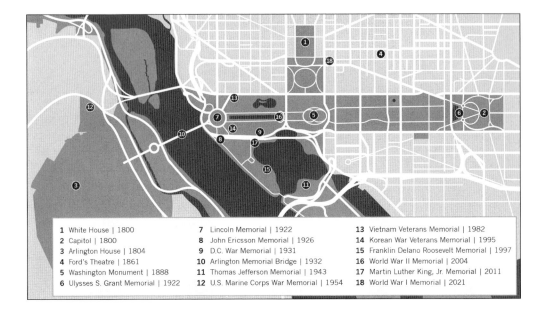

1 White House	1800	**7** Lincoln Memorial	1922	**13** Vietnam Veterans Memorial	1982
2 Capitol	1800	**8** John Ericsson Memorial	1926	**14** Korean War Veterans Memorial	1995
3 Arlington House	1804	**9** D.C. War Memorial	1931	**15** Franklin Delano Roosevelt Memorial	1997
4 Ford's Theatre	1861	**10** Arlington Memorial Bridge	1932	**16** World War II Memorial	2004
5 Washington Monument	1888	**11** Thomas Jefferson Memorial	1943	**17** Martin Luther King, Jr. Memorial	2011
6 Ulysses S. Grant Memorial	1922	**12** U.S. Marine Corps War Memorial	1954	**18** World War I Memorial	2021

The Lincoln Memorial sits on the northeast bank of the Potomac River on land that used to be river bottom, anchoring a two-mile stretch to the east that terminates at the Capitol building. Arlington Memorial Bridge and Virginia's Arlington National Cemetery lie to the southwest. Bisecting this line on a north-south axis are the White House, Washington Monument, and Thomas Jefferson Memorial. Throughout the area are monuments and memorials dedicated to important national events and figures. The map above shows the locations of key sites that predate and postdate the Lincoln Memorial. (Above, Sarah Gilbert; below, LOC.)

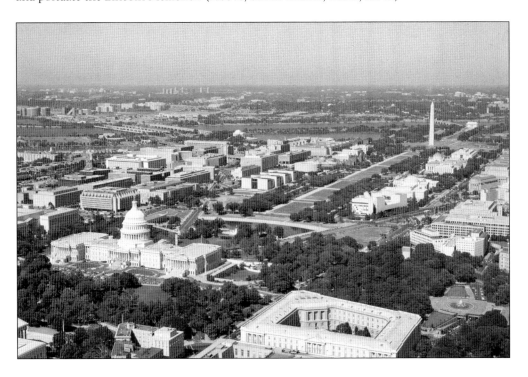

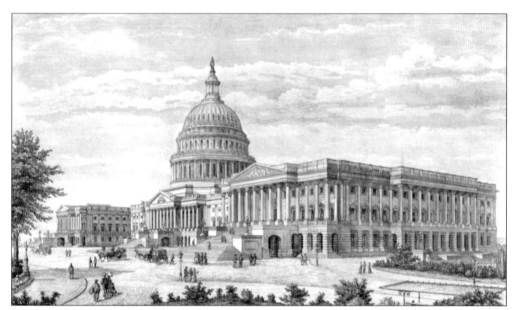

The Lincoln Memorial is located on a line of two preexisting structures in Washington, DC—the US Capitol and the Washington Monument. The Capitol, the building around which Pierre L'Enfant's design of Washington revolved, was deemed sufficiently complete to be used as the seat of Congress in 1800, although it continued to be expanded and modernized over the next 150 years. The Washington Monument—1.5 miles west of the Capitol—is the tallest building in the nation's capital. Built to honor the "Father of the Country," it is intended to be both impressive and elegant. (Both, LOC.)

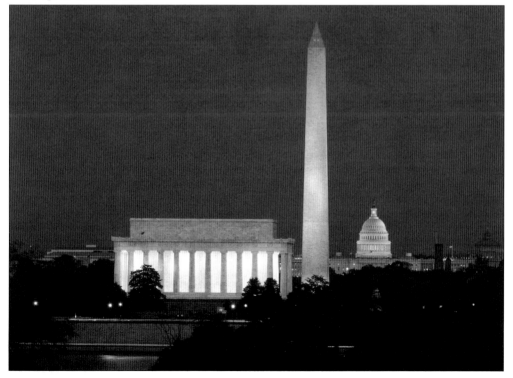

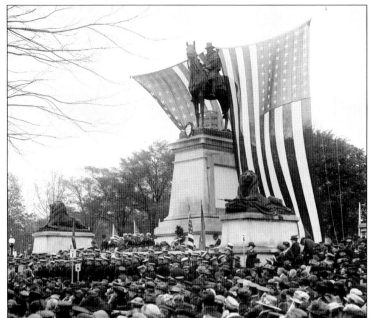

The Ulysses S. Grant Memorial sits at the foot of the Capitol at the eastern terminus of the National Mall. It includes a 2.5-times-life-size statue of Grant astride his horse, looking west toward Lincoln's east-facing statue, symbolizing their partnership in saving the Union. The Grant memorial is shown here during its April 1922 dedication, shortly before the Lincoln Memorial opened. (LOC.)

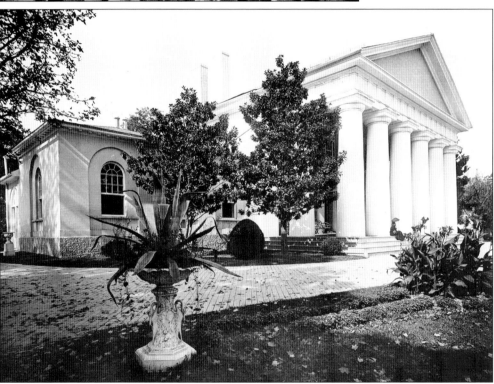

The third preexisting location to which the Lincoln Memorial relates is across the Potomac River toward the southwest. The Curtis-Lee mansion (also known as the Arlington House) where Robert E. Lee lived before assuming command of the Confederate army of Northern Virginia is now in Arlington National Cemetery because Union soldiers killed in battle were buried on Lee's surrounding farmland. It eventually became the nation's premier military cemetery. (LOC.)

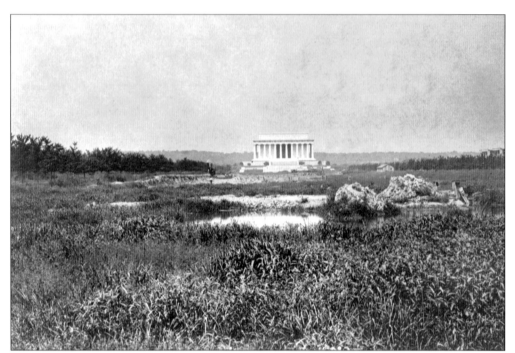

From the national capital's founding through the Lincoln Memorial's construction, the land between the Washington Monument and the Potomac River was an undeveloped tidal swamp, as seen in the 1917 photograph above. The McMillan Plan extended the formal landscape of the National Mall into this area. Henry Bacon's 1911 design included a "large lagoon" between the Washington Monument and Lincoln Memorial that would introduce "repose and beauty." Although Bacon originally envisioned a long east-west canal with water-filled "cross-arms" extending north and south at Twenty-first Street, the final 1922 design eliminated the cross-arms due to construction of temporary military buildings just north of the proposed canal in 1918. It also included paths, grass, and trees to create a balance between formality and a parklike setting. The image at right shows construction of the Reflecting Pool and surroundings. (Both, LOC.)

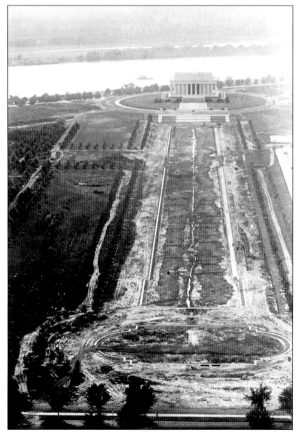

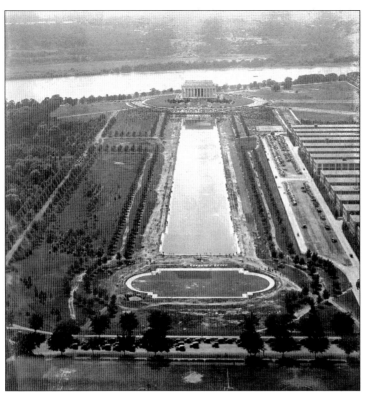

The Reflecting Pool measures 2,028 feet long by 167 feet wide. The bottom is V-shaped on its long axis, giving the pool a depth of 30 inches in the middle and 18 inches at the sides. When full, it can hold nearly 6.8 million gallons of water. The pool is lined with Mount Airy granite, mined from the world's largest open-faced granite quarry in Mount Airy, North Carolina. This is supplemented by a waterproof base of asphalt, slate, and tile. Excavation began in November 1919, and the basic foundation work was finished by 1921. (Both, LOC.)

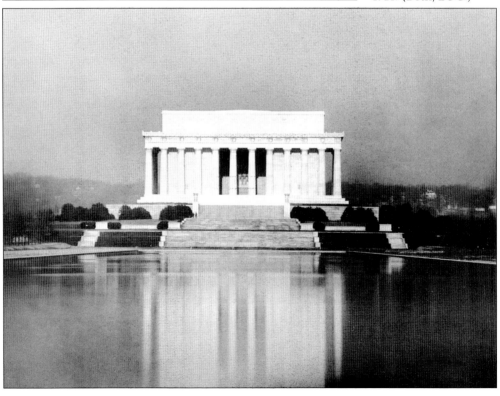

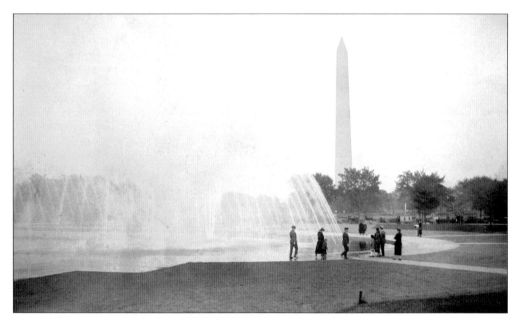

As a final component of the McMillan Plan, the Army Corps of Engineers built an oval reflecting pool with water fountains, designed by landscape artist Frederick Law Olmsted Jr., just east of the canal-shaped Reflecting Pool. Because the pool, completed in 1924, created a "perfect rainbow" when the 124 water nozzles were on, it acquired the name Rainbow Pool. The pool was later incorporated into the World War II Memorial, which required an act of Congress to address concerns that doing so would unlawfully cause the new memorial to occupy land already included within the scope of the Lincoln Memorial. The picture below shows two military officers turning on the pool in 1924. (Both, LOC.)

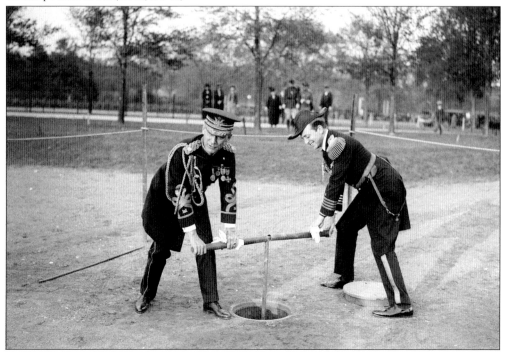

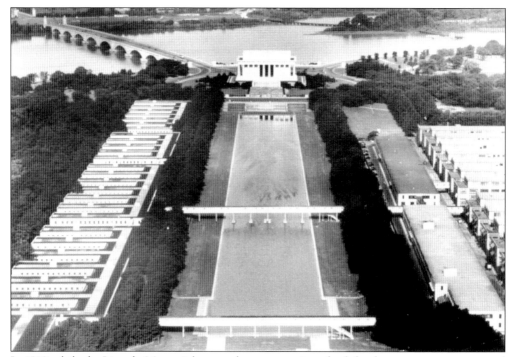

In 1918, while the Lincoln Memorial was under construction, the federal government constructed two massive "temporary" concrete office buildings north of the Reflecting Pool for use by World War I military workers. Even after the Pentagon was built in the early 1940s, they remained occupied by government employees. More "Tempos" were built south of the Reflecting Pool and near the Washington Monument. In 1942, workers installed two covered pedestrian bridges that crossed the pool and connected the buildings (above). In the 1970s, Pres. Richard Nixon, who had worked in one of the Tempos as a World War II naval officer, ordered them torn down. Those to the north of the Reflecting Pool were replaced by the 50-acre Constitution Gardens, shown below. Featuring a man-made lake, meandering paths, meadows, and trees, the gardens were dedicated in 1976 in honor of the nation's 200th anniversary. (Above, NPS; below, LOC.)

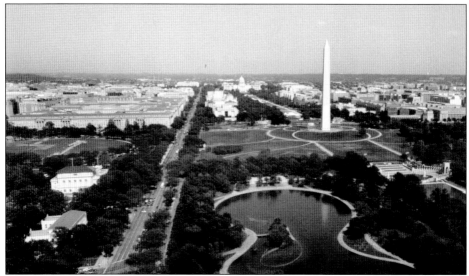

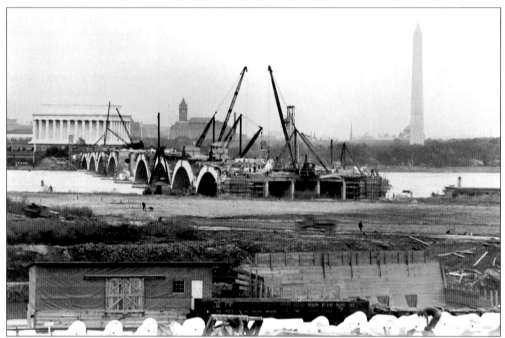

In 1926, after decades of discussion, construction began on a bridge from the west end of the National Mall to the Virginia shore near Arlington National Cemetery. Completed in 1932, the masonry, steel, and stone arch bridge includes sculptures depicting eagles and vases and bas-relief bison, poppies, and oak leaves representing national strength and unity. Originally built as a drawbridge, it ceased to function as one in 1961. The bridge runs along a direct line from the Lincoln Memorial to Arlington House (the Curtis-Lee mansion). This acknowledges Lincoln's and Lee's adversarial relationship, while connecting the former Union and Confederacy. (Both, LOC.)

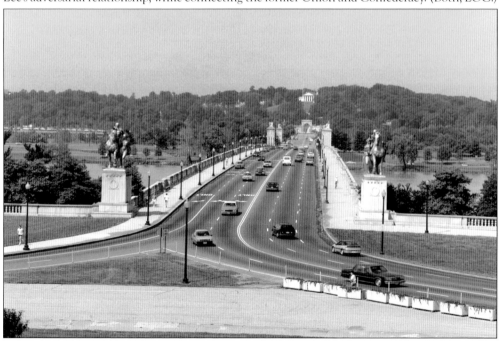

In 1931, Pres. Herbert Hoover dedicated the District of Columbia War Memorial (above) in a grove of trees south of the Reflecting Pool. It honored all citizens of the district who served in World War I, listing them in alphabetical order regardless of rank, gender, or race. Some visitors mistook it for a national memorial until the National World War I Memorial opened in 2021 on Pennsylvania Avenue near the White House (below). The central feature of this new memorial, at the former Pershing Park, is a 60-foot wall on which a sculpture depicts a reluctant soldier's journey to battle and his heroic return home. Pending completion of the project, a canvas of sketches depicting the sculpture was hung in its place. (Above, LOC; below, NPS.)

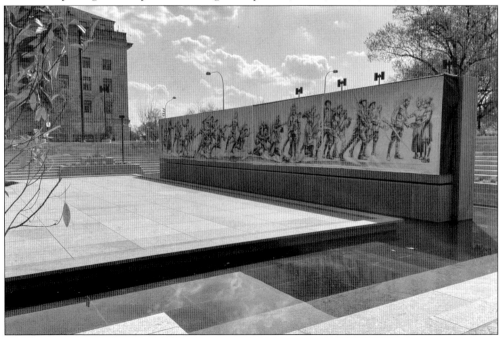

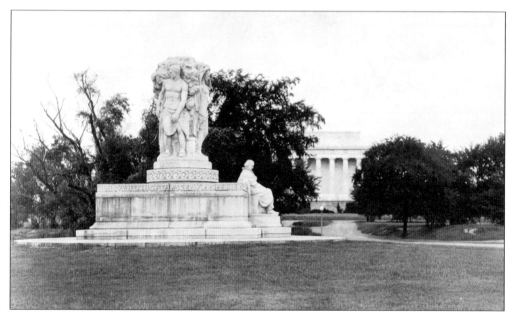

Shortly after the Lincoln Memorial opened, the Commission on Fine Arts approved a memorial to John Ericsson, Swedish-born inventor of the screw propeller and designer of the US Navy's Civil War–era ironclad warship the *USS Monitor*. The monument, completed in 1932, is set in a small traffic circle due south of the Lincoln Memorial near the banks of the Potomac River. (LOC.)

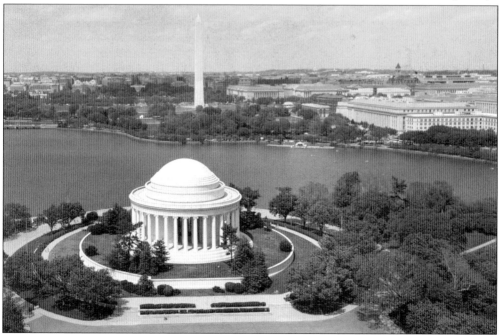

The Jefferson Memorial honors Thomas Jefferson, author of the Declaration of Independence and third president of the United States. Situated south of the White House between the Tidal Basin and Potomac River, the memorial, designed by John Russell Pope and modeled on Rome's Pantheon, was dedicated in 1943, completing the McMillan Commission's four-point design plan linking the White House, Tidal Basin, Capitol, and Lincoln Memorial. (LOC.)

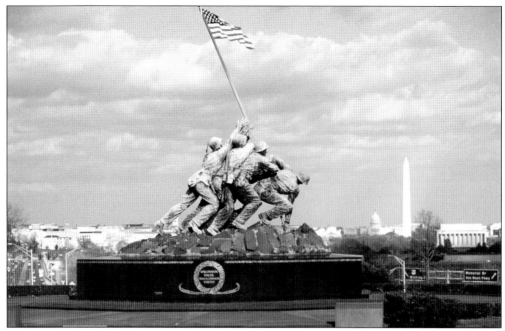

The Marine Corps War Memorial, next to Arlington National Cemetery, is a bronze statue that depicts the moment during World War II when a group of marines, having just captured the tallest point on the western Pacific island of Iwo Jima from Japanese forces, planted a US flag on the summit. The memorial was completed and dedicated in 1954. (NA.)

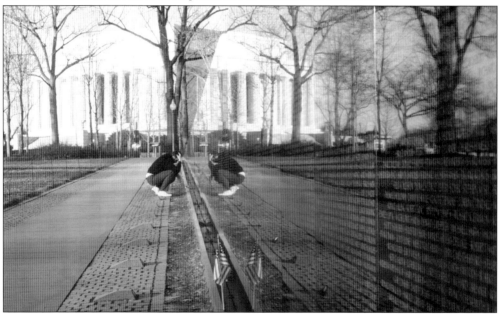

The Lincoln Memorial's identification with anti-war protests and national reconciliation prompted the Vietnam Veterans Memorial to be located nearby. Maya Lin, a 21-year-old architecture student, won the nationwide design competition. The memorial, opened in 1982, features two polished black granite walls descending into the ground in a V pointing to the Lincoln Memorial and Washington Monument, and identifying by name every killed or missing soldier. (NA.)

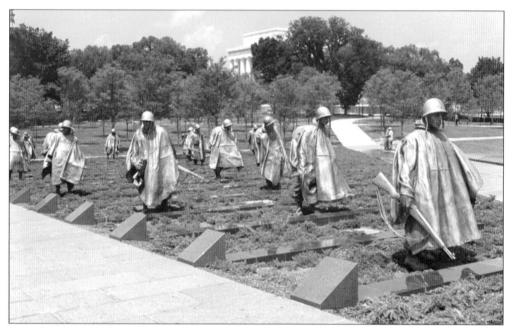

Also nearby, the Korean War Veterans Memorial, opened in 1995, features a triangular area containing 19 statues that depict a poncho-clad platoon on patrol in rough terrain, bordered by walls containing sandblasted murals that display more than 2,500 images of the war and a circular "pool of remembrance" surrounded by trees. (NA.)

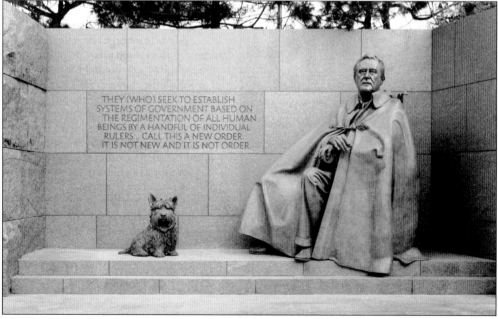

THEY (WHO) SEEK TO ESTABLISH
SYSTEMS OF GOVERNMENT BASED ON
THE REGIMENTATION OF ALL HUMAN
BEINGS BY A HANDFUL OF INDIVIDUAL
RULERS... CALL THIS A NEW ORDER.
IT IS NOT NEW AND IT IS NOT ORDER.

The Franklin Delano Roosevelt Memorial, dedicated in 1997, honors the 32nd president. Located next to the Tidal Basin, this memorial includes four outdoor "rooms" containing stone, sculptures, and waterfalls that illustrate Roosevelt's handling of an economic depression and world war during his four terms in office. A Prologue Room, added in 2001, shows Roosevelt in a wheelchair, acknowledging the physical disability caused by polio that he downplayed during his presidency. (LOC.)

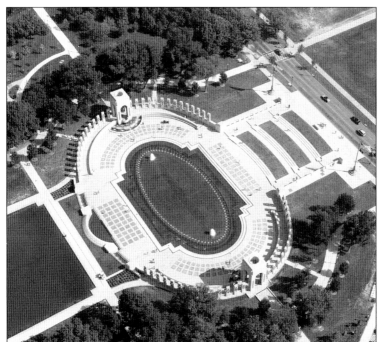

The World War II Memorial, completed in 2004, is near the Washington Monument along an axis from the Lincoln Memorial to the Capitol. The seven-acre site contains an oval plaza and fountain surrounded by semicircular walls to the north and south illustrating the war's European and Pacific theaters, behind which are 56 pillars inscribed with the names of the then existing states and territories. (LOC.)

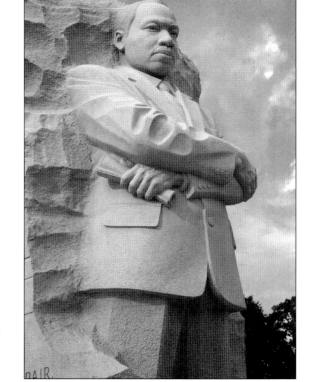

The Martin Luther King Jr. Memorial, opened in 2011, sits along a "line of leadership" connecting the Lincoln and Jefferson Memorials. Its design, a sculpture of King embedded in a large granite "stone of hope" emerging from a granite "mountain of despair," was inspired by a line from King's "I Have a Dream" speech. (LOC.)

Designing the landscaping surrounding the Lincoln Memorial presented the challenge of tying the memorial into the National Mall to the east, linking it to roads and walkways along the river and downtown Washington, and creating an entry point for a bridge from Virginia. The Fine Arts Commission adopted Henry Bacon's vision of the memorial as an "island in a park," surrounded by a "great circle" of roads leading to the memorial. (LOC.)

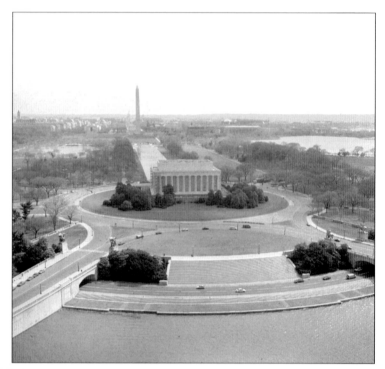

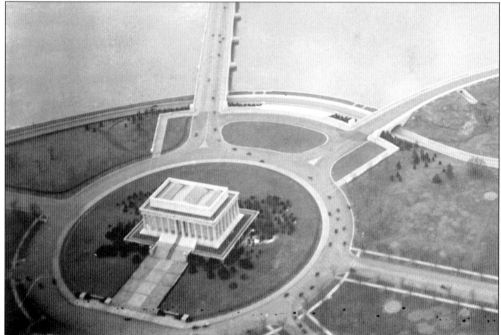

The Lincoln Memorial's designers envisioned it as the western anchor of a West Potomac Park containing meadows, trees, paths, water elements, and monuments. But construction of the Memorial Bridge, transformation of nearby roads into commuter routes, and growth of the DC region created congestion. In the 1940s, the road system surrounding the memorial was redesigned and expanded to accommodate more traffic while preserving the beauty of the nearby grounds. (LOC.)

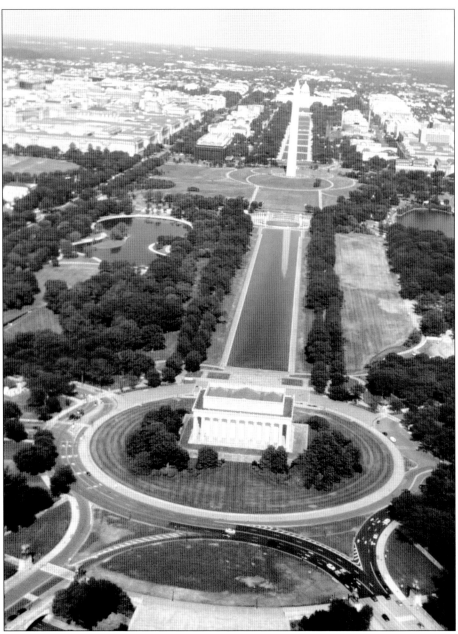

Sometime in the 1920s, real estate professionals in the United States began using a phrase to indicate the value of property—"location, location, location"—that could easily have been applied to the recently opened Lincoln Memorial. That sentiment would ring as true today as it did a century ago. The memorial serves as the western anchor of the National Mall axis that extends past the Washington Monument and terminates on the eastern end at the US Capitol. This makes it centrally located in one of the globe's leading political cities, the "Capital of the Free World," as Washington, DC, has been described. And it serves as a hub for other monuments to American ideals and the people who fought to maintain them—Thomas Jefferson, Martin Luther King Jr., and Franklin Delano Roosevelt—and to shrines recognizing the many warriors who defended the country in armed conflicts and gave their last full measure of devotion. (KS.)

Five

THE MEMORIAL BUILDING

The Lincoln Memorial resembles the Athenian Parthenon, featuring columns, friezes, wide steps, platforms, and statuary. All of these elements have symbolic meaning. Walking up the stairways to the memorial impresses the visitor, who takes in the surroundings, considers the structure, and eventually spots the statue of Abraham Lincoln within. The columns convey history and dignity, suggesting that Lincoln is just as worthy as the leaders of ancient Greece. The friezes around the upper levels of the building with their listing of all the states and filigree of plants from the North and South remind people that Lincoln's skillful prosecution of the Civil War enabled the country to eventually reunite into one nation, which in subsequent decades added new states, developed its economy, and became an important world power.

The interior of the Lincoln Memorial is vast. Its ceiling is as high as a four-story building, its depth is the length of two telephone poles, and its width is the length of three semitrailers. But its design is simple and understated and its contents limited. It consists of three chambers. The central hall contains a statue of a seated Abraham Lincoln with an engraved inscription above and behind his head. The chamber to the visitor's left, beyond a set of columns, contains an engraving of the Gettysburg Address with a mural illustrating the themes from that 1863 speech. The chamber to the right, again beyond columns, contains the text of Lincoln's second inaugural address in 1865 and, above it, a mural illustrating the themes from that speech. In this starkness lies the emotional and intellectual power of the memorial.

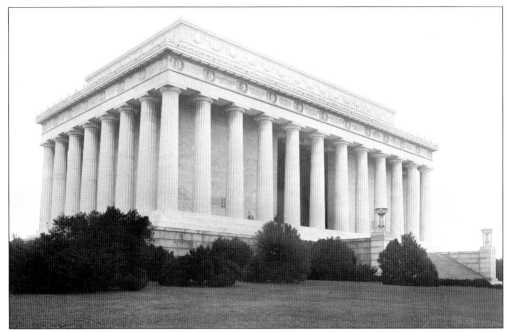

The Lincoln Memorial building (above) is modeled on the Parthenon in Athens (below) because designer Henry Bacon wanted to link Lincoln's saving of the Union to the alliances of ancient Greece, where democracy was born. The memorial's exterior is defined by a peristyle (a colonnade surrounding a building or court) of 38 Doric columns that are 44 feet tall. The outer 36 columns represent the number of states in the Union at the time of Lincoln's death. Two more columns stand behind the outer columns at the front entrance to the interior chambers. The columns communicate the importance of national unity—all of the columns working together allow the building to stand; if too many of them were removed, the structure would fall. (Both, LOC.)

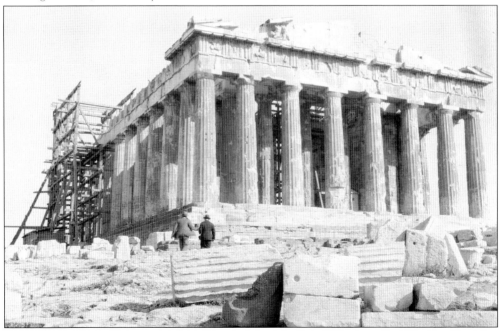

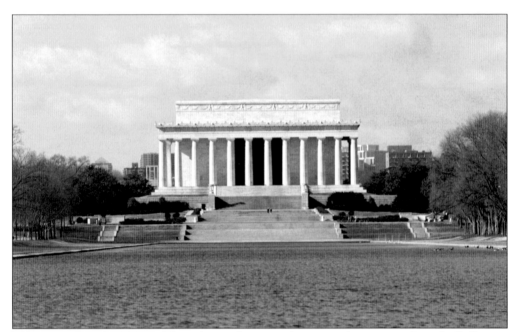

The approach to the memorial from the east begins with a series of steps rising from the Reflecting Pool to a road that encircles the building. As shown on this book's cover, the road was originally opened to traffic but was eventually limited to pedestrians and emergency vehicles. Beyond the road is a series of additional steps and platforms that eventually lead to the main level of the memorial. From a distance, this gives the appearance that the memorial rests on an elevated grassy knoll. The interspersion of steps and platforms gives visitors a chance to stop and look around while ascending to the memorial's main level. (Both, LOC.)

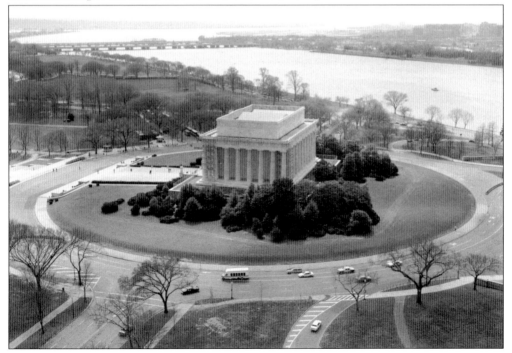

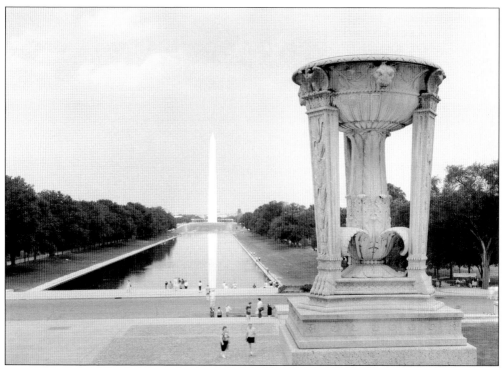

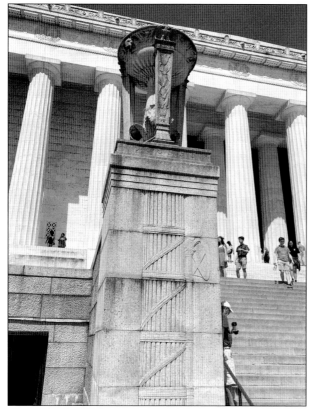

Flanking the memorial's steps are two tripod braziers (a container used to hold a fire) standing 11 feet tall. The tripods contain symbolic elements, including eagles, corncobs, and pine cones. The faces of the parapets below the tripods contain bas-reliefs of fasces (a bundle of rods tied together) capped by tomahawks containing an eagle's head. A symbol that originates in ancient Rome, the fasces communicate the power of unity—many rods joined together are stronger than separate individual rods. The axe sometimes found on fasces, as here, symbolizes the use of force. The eagle's head on these fasces give them an American identity. In short, the fasces at the memorial's entrance convey to the visitor the importance of national unity and that Lincoln deployed military force to preserve it. (Both, LOC.)

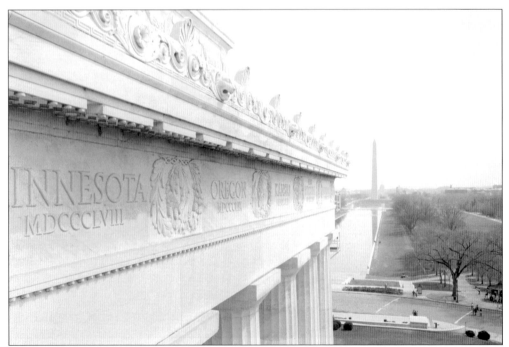

Above the colonnade (row of columns) is a frieze (a horizontal band of decoration) wrapping around all four sides of the memorial. The frieze contains the names of the 36 states in the Union at the time of Lincoln's death and the dates of their admission in Roman numerals. (The memorial is replete with symbols from the Roman Empire, reflecting the designers' views about America's parallels with it.) The list begins with the first state, Delaware, on the left side of the memorial's east front, and winds around the frieze in order of admission. Advancing the memorial's theme of national reconciliation, the states' names are separated by double wreaths of longleaf pine with cones (representing the South) and northern laurel (representing the North). (Both, LOC.)

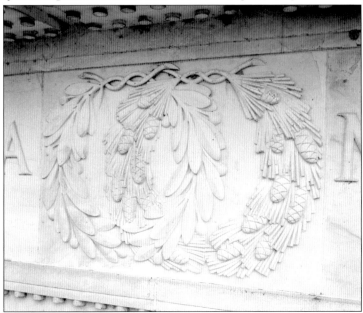

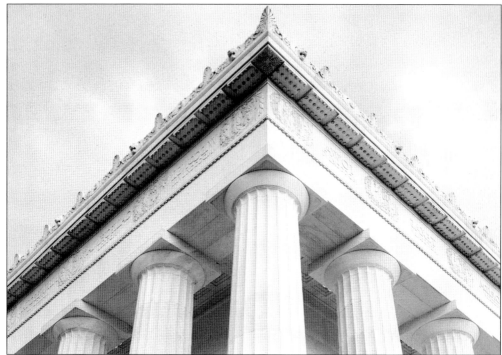

Capping the lower frieze is a cornice (an ornamental molding) containing a carved scroll with lions' heads and palmetto. At the top of the building and set back from its perimeter is the "attic frieze," on which are inscribed the names of the 48 states in the Union at the time of the memorial's dedication in 1922 with their dates of admission in Roman numerals as on the lower frieze. This list again begins with Delaware, starting on the left of the west (back) side of the memorial and winding around, concluding with Arizona (admitted in 1912) on the right end of the north face. Above the list of states at the parapet of the building is a garland decorated with ribbons and palm leaves, periodically interspersed by eagles and tripod braziers. (Both, LOC.)

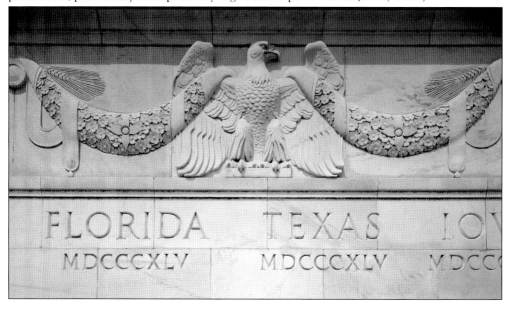

Hawaii and Alaska became states in 1959. This led to a debate about how to add references to them to the Lincoln Memorial, including a proposal to carve the states' names into the memorial's front entrance walls. In 1985, the debate was resolved when a plaque was installed on the plaza in front of the memorial referencing the two later-admitted states. (LOC.)

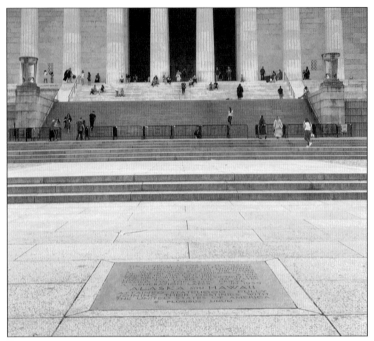

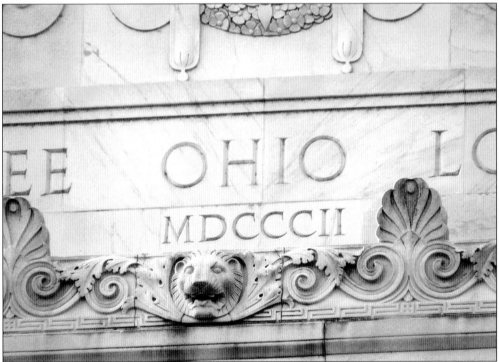

The year of Ohio's admission, 1802, is incorrectly stated on both the lower and upper friezes. Although Congress authorized Ohioans to write a state constitution in 1802, Ohio's state government did not begin operation until 1803. To avoid confusion, in 1953 Congress retroactively admitted Ohio to the Union effective 1803. Thus, while Ohio's admission year as carved on the building was correct in 1922, it was later declared incorrect. (KS.)

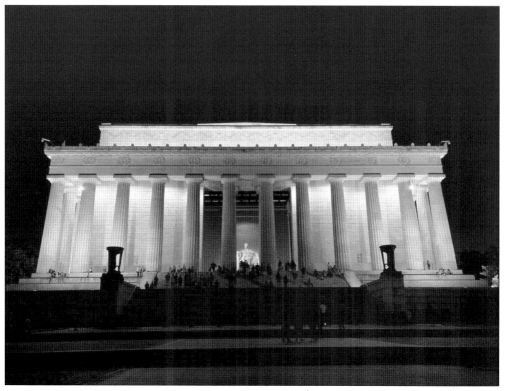

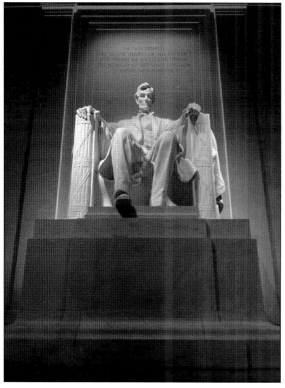

The exterior and interior of the Lincoln Memorial evoke different emotions and convey different messages. The building's outside, with its white marble, stocky Doric columns, friezes, and imposing setting, conveys power and invokes a sense of awe. It tells the visitor that America is, and will remain, a great power because the previously warring states are now reunified due to Lincoln's perseverance and wisdom as commander in chief. Inside the building, triumphalism is replaced with reflection. The light is dimmer, the stone walls and floors are darker, the columns are thinner Ionic ones, and the visitor's focus turns to Abraham Lincoln the human being—what he looked like, what his demeanor was, what his values and principles were, and how he communicated his views to the public. (Both, KS.)

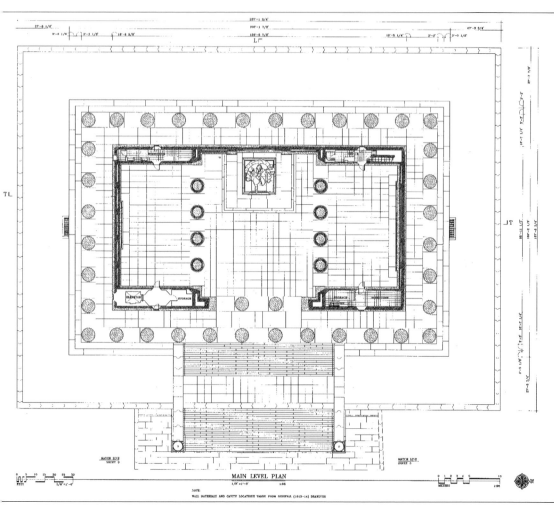

MAIN LEVEL PLAN

As shown in this blueprint, the interior of the building is divided into three chambers separated by columns. Lying between the south and north chambers is the central hall, which contains the large, seated statue of Abraham Lincoln. This central hall, which faces east to the Reflecting Pool, Washington Monument, and Capitol, is 60 feet wide, 74 feet deep, and 60 feet high. The south chamber (to the left in this drawing) and north chamber (to the right) are each highlighted by engravings of two of Abraham Lincoln's most iconic speeches—the Gettysburg Address and his second inaugural address—topped by 60-foot-by-12-foot murals by Jules Guérin portraying scenes that represent some of Lincoln's governing principles. Besides the engravings and murals and minimal symbolic features associated with them, the chambers are bare of other elements, resulting in a simple, elegant atmosphere that reinforces the austere grandeur of the shrine. (LOC.)

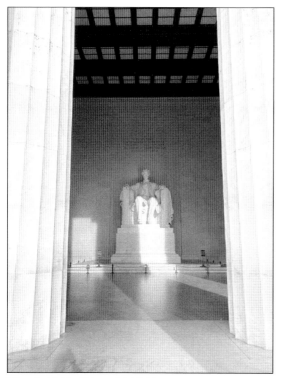

Although designer Henry Bacon initially wanted to leave the wall behind the Lincoln statue blank, he later decided that an inscription above and behind Lincoln's head would help visitors focus their attention on Lincoln. He asked his friend, art critic Royal Cortissoz, to compose something suitable. His words convey the memorial's central theme: that Lincoln "saved the Union," for which "the people" (from both Northern and Southern states) are now so grateful that they erected this "temple" to "enshrine" his "memory." Some people objected to including in the memorial anything not written by Lincoln. Others felt the phrase mawkish and tried to have it removed. (Left, KS; below, NPS.)

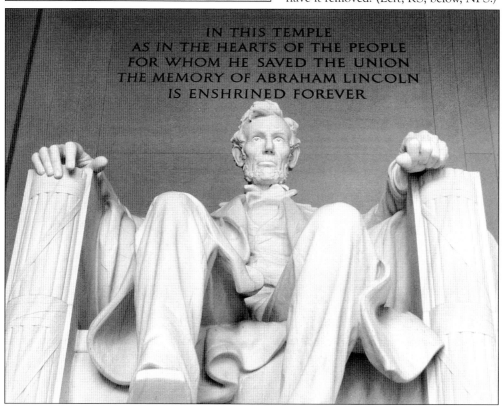

After initially planning a statue of Lincoln standing, project architect Henry Bacon decided on a seated figure because that was how Western sculpture traditionally honored dead statesmen. Bacon chose sculptor Daniel Chester French (who had created the minuteman statue in Concord, Massachusetts) to design the statue because he had worked well with him in the past. They are shown at right supervising its assembly. To prepare, French researched Lincoln, interviewed his son Robert, and studied photographs and casts of Lincoln's face and hands. His design showed Lincoln seated in a throne-like chair dressed in a frock coat gazing downward with a look that combines wisdom, strength, and fatigue. (Both, LOC.)

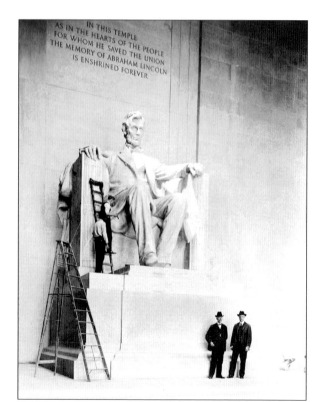

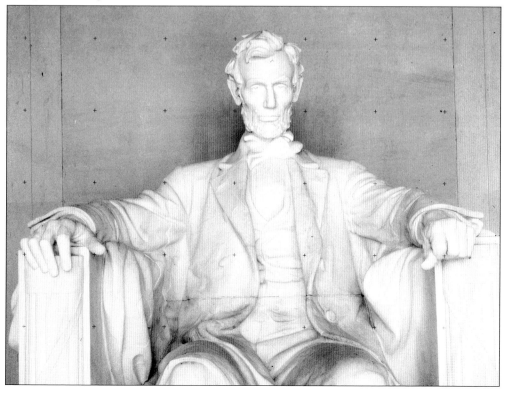

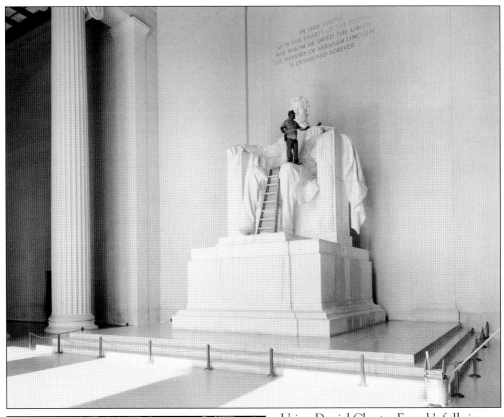

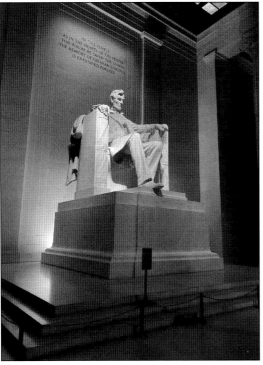

Using Daniel Chester French's full-size final sculpture, the Piccirilli brothers (who also created the marble Roman tripods on the parapets on the stairway leading up to the building) carved 28 pieces of white Georgia marble into blocks that, when assembled over several months beginning in November 1919, created a finished statue weighing 340,000 pounds. The statue sits on a pedestal of Tennessee marble 10 feet high, 16 feet wide, and 17 feet deep. Below this is a larger platform, also of Tennessee marble, about 34 feet long, 28 feet wide, and six inches high. The top of Lincoln's head is about 30 feet above the ground. Had Lincoln been depicted standing, he would be 28 feet tall. (Both, LOC.)

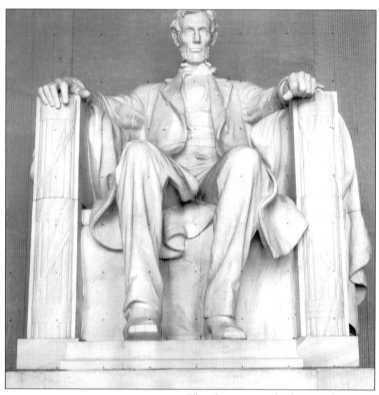

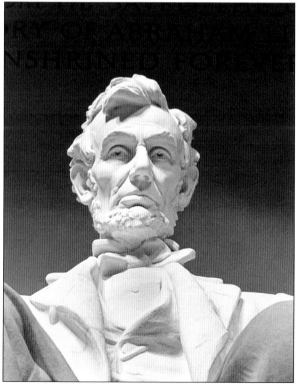

The throne on which Lincoln sits represents the grandeur of the government he led. He is dressed in a vest and frock coat—the garb of his era. An American flag draped over the back suggests an emperor's toga. Lincoln's left hand is balled in a fist, suggesting firmness. His right hand is open, suggesting his willingness to listen. The front of Lincoln's chair contains Roman fasces, again reminding visitors of a presidency consumed by efforts to reunify the country. If it seems strange for an American presidential memorial to feature a symbol that has been associated with fascism, bear in mind that it was designed and built before the fasces symbol and term became tarnished by the rulers of Italy and Germany in World War II. (Both, LOC.)

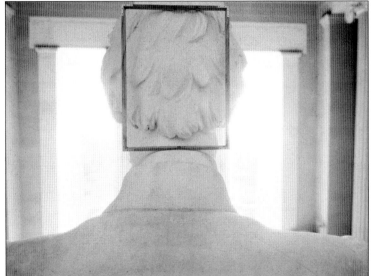

A legend holds that the face of Robert E. Lee is carved onto the back of Lincoln's head. Lee is said to be looking across the Potomac toward his former home (now within Arlington National Cemetery). The National Park Service's position is that no evidence exists suggesting that the sculptors intended to include this subliminal message. (LOC.)

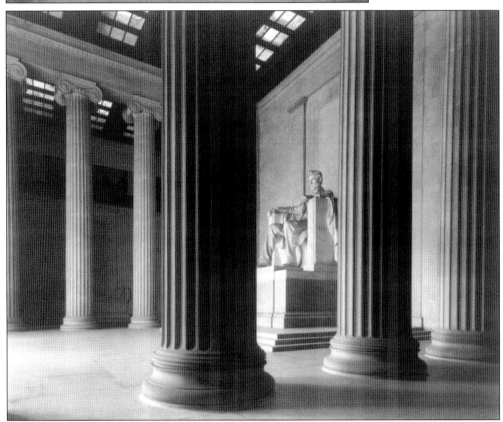

To the south and north of the room containing the Lincoln statue and separated by rows of four five-foot-high Ionic columns are chambers featuring engravings of two of Abraham Lincoln's most notable speeches—both of which allude to his opposition to slavery. This design allows visitors to reflect on Lincoln's words and thoughts, while providing some seclusion from the often-crowded central chamber. (LOC.)

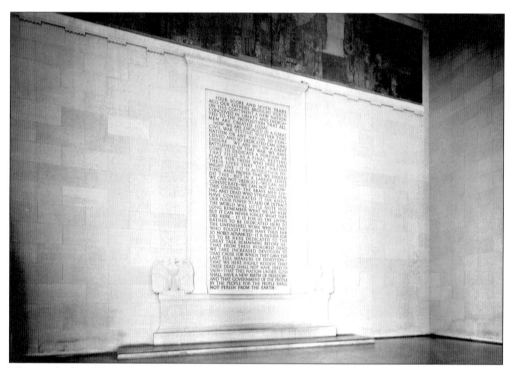

The south chamber contains an engraving of the Gettysburg Address, which Lincoln delivered on November 19, 1863. In it, Lincoln declared that the objectives for which Union soldiers fought and died involved bringing about "a new birth of freedom" (the end of slavery) and ensuring that "government of the people, by the people, for the people shall not perish from the Earth." The speech is framed by cornstalks and two bald eagles. On the frieze below are carvings of the northern laurel, perhaps an allusion to the fact that the Gettysburg Address was aimed primarily at a Union audience. (Both, LOC.)

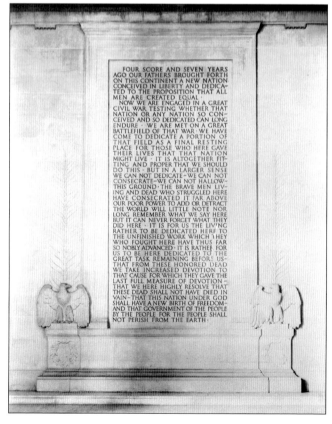

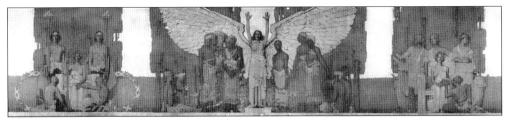

The 60-foot-by-12-foot mural above the Gettysburg Address is called *Emancipation*. The center panel depicts slaves being released from bondage. The left side represents Justice and Law, while the right represents Faith, Hope, and Charity. The painting includes kerosene and wax to protect it. Unfortunately, its elevation and poor lighting make it difficult for the visitor to discern its detail and meaning. (NPS.)

An elevator is on the east side of the south chamber. It allows visitors access to a lower level, containing restrooms and an exhibit area. Featured there is the Lincoln's Legacy exhibit, which tells the story of historic events that have taken place at the memorial since its opening. It was funded by Arizona school students through a program called "Pennies Make a Monumental Difference." (KS.)

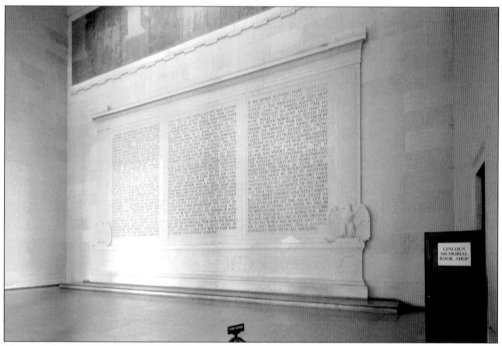

The north chamber contains an engraving of Lincoln's second inaugural address, in which he talked about the need to "bind up the nation's wounds" once the war came to an end. The speech is bracketed on each side by the Roman fasces symbol (reminding the viewer of Lincoln's continued power when he gave the speech), below which is a bas-relief of a bald eagle, the national bird. A frieze below the speech contains alternating wreaths of longleaf pine with pinecones and northern laurel, a reference to national reconciliation. In the line from the second inaugural address, "With high hope for the future," the F in "future" was mistakenly carved as an E. To obscure this error, the bottom line of the E is not painted black. (Above, LOC; below KS.)

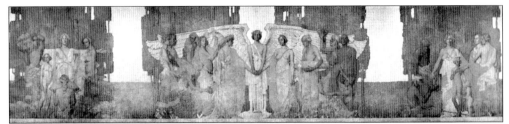

The allegorical mural above the second inaugural address, called *Reunion*, features the Angel of Truth holding the hands of two figures representing Northern and Southern states. Her wings cradle figures representing Painting, Philosophy, Music, Architecture, Chemistry, Literature, and Sculpture. Emerging from behind the Music figure is the veiled image of the future. The left group represents Fraternity, while the right represents Charity. (NPS.)

Behind the east wall of the north chamber is a small shop that sells books and souvenirs about the Lincoln Memorial, Lincoln, and the Civil War as well as maps, cold drinks, and other merchandise. Unlike some newer memorials that have self-contained stores, restrooms, and other support facilities, such resources are scattered throughout this memorial. (KS.)

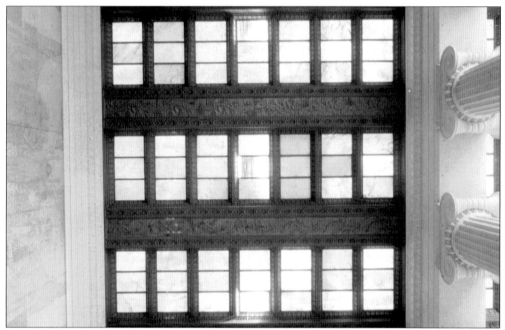

While the key points of interest inside the Lincoln Memorial are the statue, inscriptions, and, to a lesser degree, the paintings, there are also many intriguing architectural elements. The variety of building stones, the arrangement of the columns, and the artistic details on the statue and walls are all meaningful. So is the distinctive ceiling, consisting of panels of nearly pure Alabama marble crossed with bronze beams decorated with alternating patterns of leaves and other foliage. Supplementing the natural light are floodlights, although their presence is not obvious thanks to well-placed metal slats that hide them. This artificial lighting was installed in 1929 at the request of Lincoln statue designer Daniel Chester French. (Both, LOC.)

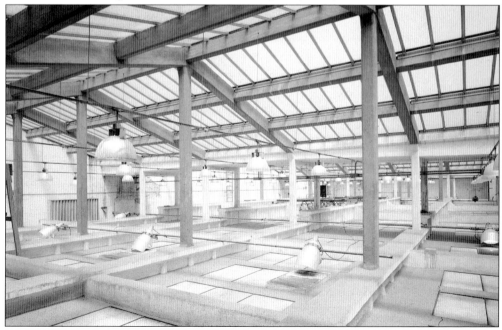

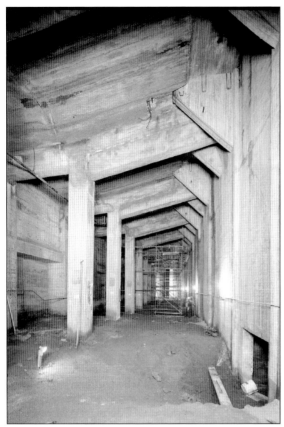

Below the memorial is a three-story basement called an undercroft. People have occasionally suggested installing exhibits there, and regular public tours occurred in the 1970s–1980s before it was closed due to the presence of asbestos. An interesting aspect of the undercroft is the formation of stalactites. Much like in a naturally occurring cave, water dissolves some of the calcium carbonate of the marble ceiling as it seeps through it. The minerals then precipitate out as the water drips from the ceiling, over time creating stalactites. The National Park Service plans to install an exhibit area in the basement where visitors can view the undercroft through glass windows. (Both, LOC.)

Six

A Century of Memorable Events

The Lincoln Memorial has over its 100 years been the setting for ceremonies, rallies and marches, concerts and celebrations, and other events.

The first formal event at the memorial was its dedication ceremony on Memorial Day in 1922, attended by what was then a historically large, racially segregated, audience. The most famous speakers at the event, Pres. Warren G. Harding and former president (and then US Supreme Court chief justice) William Howard Taft, portrayed Lincoln and the memorial in the ways its designers intended—emphasizing his successful work to lay the seeds of national reconciliation by winning the Civil War.

Since then, the Lincoln Memorial has been the setting for events led by advocates for a wide range of causes. Black civil rights activists used the Lincoln Memorial as the backdrop for a series of events, including a 1939 Easter performance by opera singer Marian Anderson before a racially integrated audience and the 1963 March on Washington for Jobs and Freedom, at which Dr. Martin Luther King Jr. gave his iconic "I Have a Dream" speech. It has also been the setting for events focused on anti-war and anti-poverty causes, among others.

The memorial is regularly featured during moments of national importance, both celebratory and somber. Every president since Jimmy Carter has incorporated the Lincoln Memorial into his inaugural events, and Lincoln's birthday and other national holidays invariably feature a ceremony at the memorial.

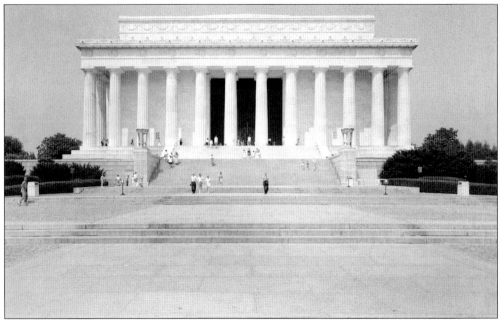

Written records say little about the planners' envisioned future uses of the Lincoln Memorial. Yet its design makes it conducive to a wide range of purposes. Its elevated terraces, large plazas, and the grassy areas running along both sides of the Reflecting Pool render the memorial well-suited for public events of all kinds and sizes. Its dignified interior spaces invite quiet contemplation by individual visitors who can study Lincoln's statue and speeches and reflect upon his legacy. Its massive size, elevated height, and visibility from different directions and from a distance means it regularly appears in the lives of Washington's residents and visitors—whether they are running on the National Mall, driving on the George Washington Parkway along the Virginia side of the Potomac River, or arriving by airplane at Washington National Airport. (Both, LOC.)

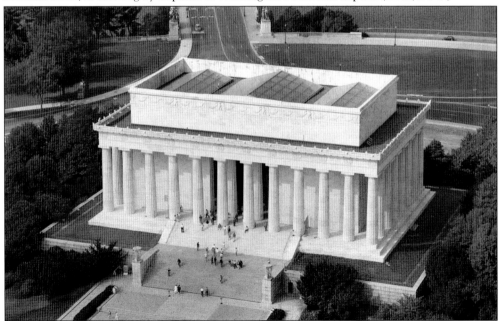

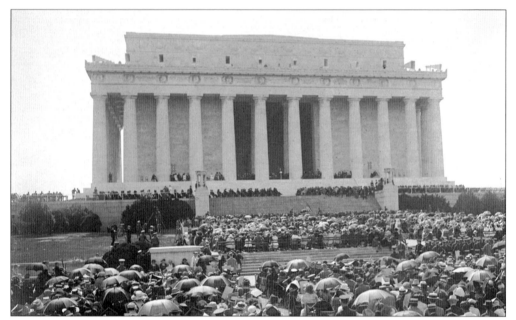

The Lincoln Memorial was dedicated and formally opened to the public in a grand ceremony on Memorial Day, May 30, 1922. While attendance estimates range from 35,000 to 50,000, the crowd is believed to have been the largest to have assembled for a public event in the capital city at that time. The live, nationwide radio broadcast of the ceremony allowed millions more to listen. The photograph above shows the event from the audience's perspective. The photograph below shows veterans, many wearing medals. While several African Americans are among them, most were assigned to sit in a marked-off segregated section patrolled by guards. (Both, LOC.)

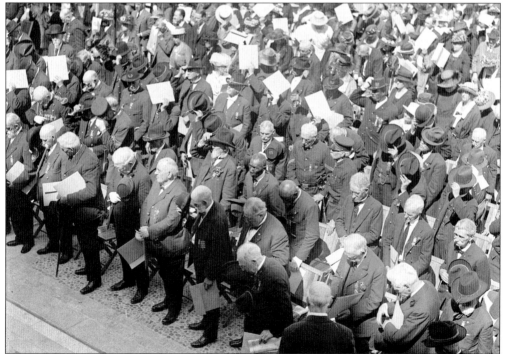

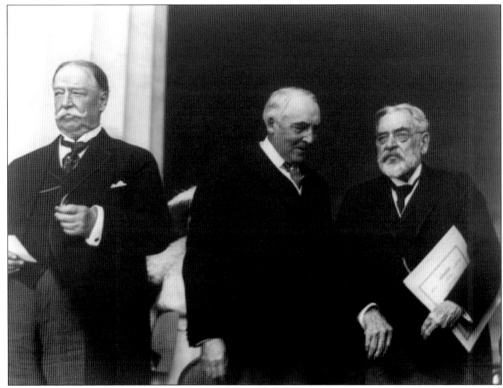

Included among the dignitaries attending the dedication were, from left to right, US Supreme Court chief justice and former president William Howard Taft as chairman of the Lincoln Memorial Commission, Pres. Warren G. Harding, and Robert Lincoln—Abraham Lincoln's only still-living child who, like his father, had become a lawyer and eventually served as secretary of war and ambassador to Great Britain in Republican administrations. (LOC.)

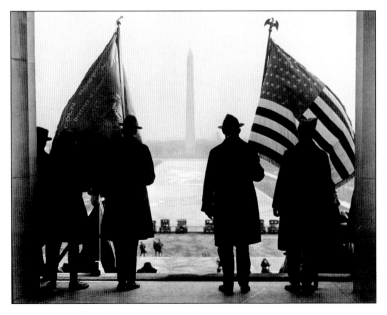

The dedication began at 2:45 p.m. with Taft bringing the crowd to attention. Next was an invocation by Rev. Wallace Radcliffe of the New York Avenue Presbyterian Church, where Lincoln had worshipped while serving as president. The Grand Army of the Republic then presented the colors (shown here) and Bishop Samuel Fallows gave a prayer of dedication. (LOC.)

The only Black person invited to speak, as organizers said, "for his race," was Dr. Robert Moton, head of the Tuskegee Industrial Institute. Moton's speech traced the nation's history of racial injustice and observed that Black Americans were still being deprived of their constitutional rights. The speech was a watered-down version of his original draft, which organizers forced him to rewrite due to what they considered its too-forceful tone. (LOC.)

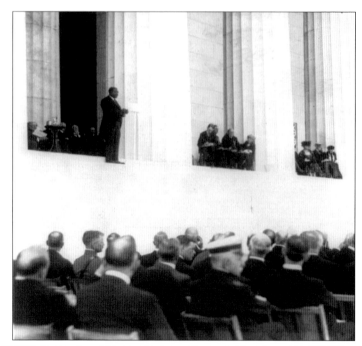

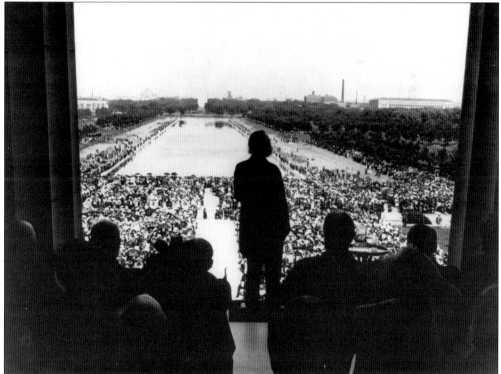

Internationally famous poet Edwin Markham, shown here, read a work entitled, "Lincoln, the Man of the People." It described Lincoln's strength and character derived from humble origins, who went from "log cabin to the Capitol" to "send the keen ax to the root of wrong" (i.e., slavery) and heroically responded "when the judgment thunders split the house" (caused the Civil War). (LOC.)

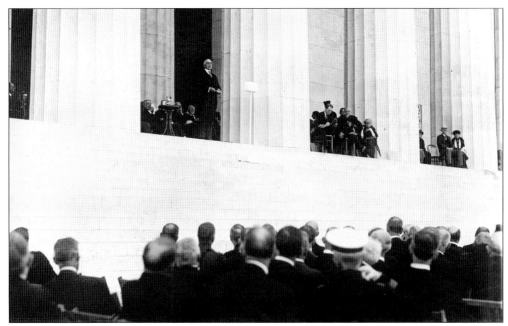

The ceremony occurred during the Jim Crow era, a period of pushback against efforts by Black citizens to exercise equal political and legal rights. The day's two most prominent speakers emphasized Lincoln's role as protector of the Union rather than as the Great Emancipator of enslaved humans. Chief Justice Taft spoke of idealism and civic religion, declaring the memorial "a sacred religious refuge in which those who love country and love God can find inspiration and repose." President Harding's remarks accepting the memorial on behalf of the nation rebuked Moton's speech, declaring that Lincoln "would have compromised with the slavery that existed, if he could have halted its extension." Instead, Harding said, Lincoln viewed emancipation as "a means to the great end—maintained union and nationality." (Both, LOC.)

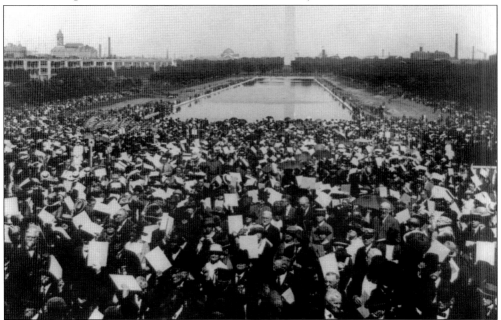

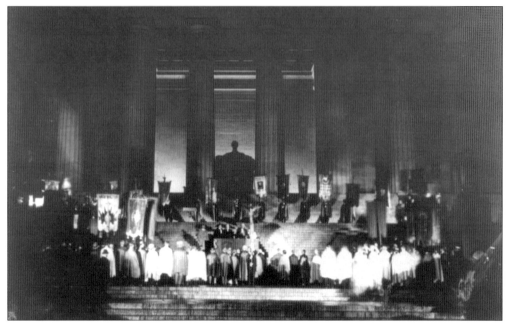

In May 1923, the American Institute of Architects (AIA) presented a tribute to the memorial's designer, Henry Bacon, with a dinner under a tent near the east end of the Reflecting Pool. After the dinner, Bacon rode a ceremonial barge along the full length of the pool. At the Lincoln steps, Chief Justice Taft presented Bacon with a gold medal. (LOC.)

After 1922, various organizations were allowed to plant memorial trees near the memorial. First Lady Grace Coolidge and the president of Oberlin College, Henry Churchill King, planted the first commemorative tree north of the memorial on November 5, 1923. Elsewhere, the American Forestry Association gave two elms, one for the Army and one for the Navy. The Boy Scouts later planted a white oak in honor of Lincoln's mother. (LOC.)

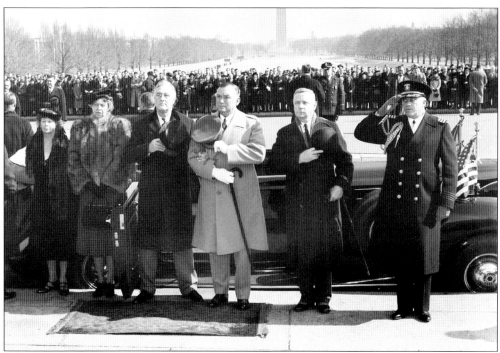

Each year on Lincoln's February 12 birthday, dignitaries, diplomats, and ordinary visitors assemble at the memorial to honor him by placing a wreath at the base of his statue and sometimes by holding special ceremonies. The image above shows Pres. Franklin Delano Roosevelt and First Lady Eleanor Roosevelt and their delegation arriving for the ceremony in 1940. In connection with the bicentennial of Lincoln's birth in 2009, Congress created a commission that organized myriad events over several years, including televised ceremonies at the memorial and at other important venues, commemorative performances and recitations of his speeches, issuances of Lincoln-themed coins and stamps, and even a weeklong bike tour from his Kentucky birthplace to Springfield, Illinois. (Above, LOC; below, US Army.)

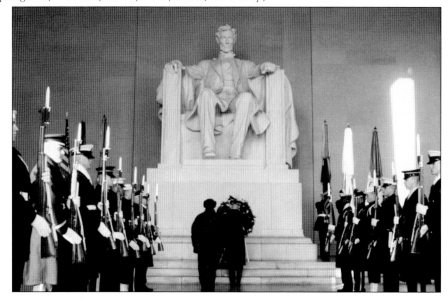

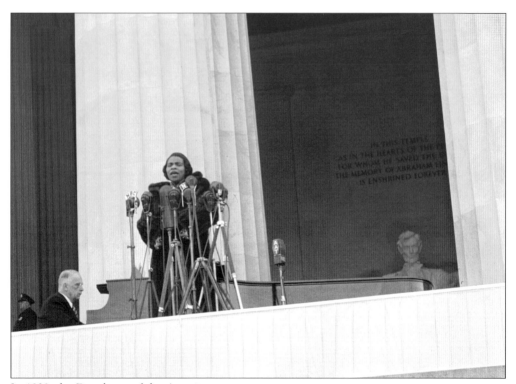

In 1939, the Daughters of the American Revolution refused to allow the world-famous African American opera singer Marian Anderson to perform at the organization's Constitution Hall. Secretary of the Interior Harold Ickes (who oversaw the National Park Service, which owns and runs the Lincoln Memorial) arranged for her to perform on the steps of the memorial on Easter Sunday before a live, racially integrated audience of 75,000 and a nationwide radio audience. This transformed the initially low-interest event into a dramatic repudiation of racial segregationists, reminding Americans of Lincoln's role as emancipator. The concert brought worldwide attention to continued racial injustice in America. Four years later, a mural called *An Incident in Contemporary American Life*, which commemorated that performance, was presented to the US Department of the Interior, where it today is displayed in its headquarters building. (Both, LOC.)

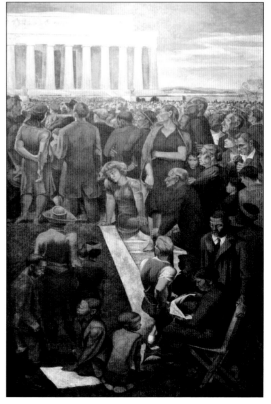

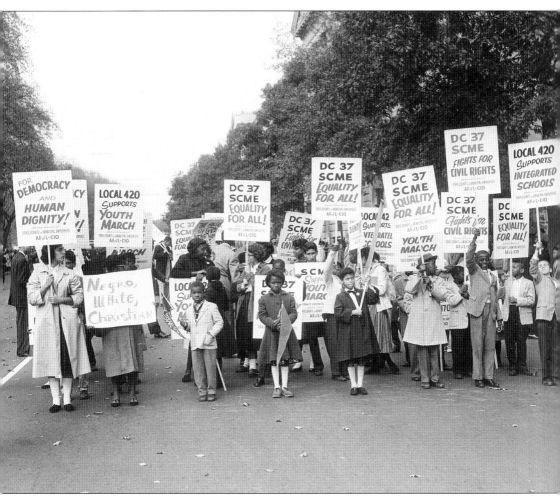

Offended by the content of the 1922 Lincoln Memorial dedication ceremony, civil rights leaders sought to, as the *Chicago Defender* (a Black-owned newspaper) said, "dedicate" the Lincoln Memorial to their struggle for equal rights. These events, which occurred primarily from the 1940s through the 1960s, featured patriotic and spiritual music, religious content, prominent speakers and guests on the speakers' platform, and references to Lincoln as the spiritual father of the civil rights movement. Pictured is an image of the October 25, 1958, Youth March for Integrated Schools. Ten thousand people—mostly high school and college students—gathered at the memorial to support desegregation of public schools across the United States. Rev. Martin Luther King Jr. was scheduled to attend and speak but missed it due to a recent assassination attempt in New York. Five years later, he would become the breakout star of a much larger event. (NA.)

The most important civil rights rally in American history occurred on August 28, 1963, when the Lincoln Memorial grounds became the site of the March on Washington for Jobs and Freedom. Held when the Kennedy administration was trying to get civil rights bills passed by Congress over opposition by Southern Democrats and some Republicans, this rally was designed to display broad, deep, and vocal multiracial political support for the legislation. Approximately 250,000 people of all races came to the event. Civil rights leaders decided to culminate the march with speeches at the Lincoln Memorial rather than the Capitol to avoid making members of Congress feel that they were personally under physical attack. (Right, LOC; below, NA.)

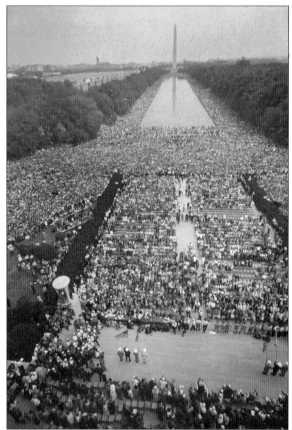

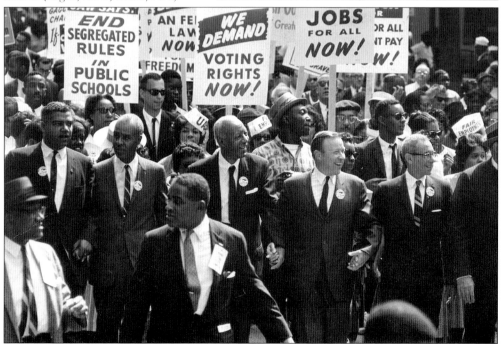

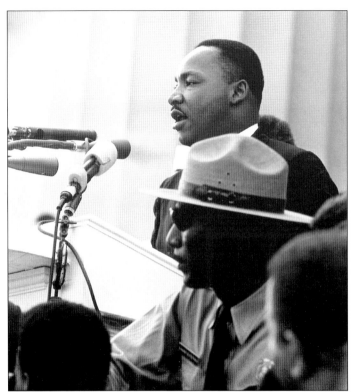

The most memorable speech was given by Dr. Martin Luther King Jr., who, like other orators, spoke from the terrace just below the memorial floor level, so that Lincoln's statue would loom behind him. King began by reminding his audience of Lincoln's 1863 Emancipation Proclamation, which sought to advance the promise in the Declaration of Independence to protect the "inalienable rights" of "all men—black men as well as white men." He voiced frustration that, a century later, the nation continued to "default on this promissory note." He affirmed the urgent need to push for equal rights, not through violence but "on the high plane of dignity and discipline." King's "I Have a Dream" speech became such a part of the Lincoln Memorial story that the spot from which he spoke has been marked. (Above, NA; right, KS.)

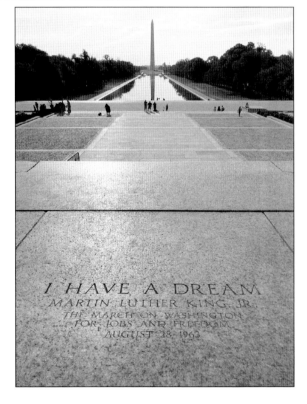

After Pres. John F. Kennedy's funeral in November 1963, his body was transported on a horse-drawn carriage around the Lincoln Memorial and across Arlington Memorial Bridge to Arlington National Cemetery. Kennedy was buried on a direct line between the Curtis-Lee Mansion and the memorial. At night, one can see the eternal flame at Kennedy's gravesite from the back of the memorial (right). Looking from the opposite direction during the day (below), the gravesite is visible in the foreground, followed by hundreds of military gravestones, the Arlington Memorial Bridge, and the Lincoln Memorial in the background. (Right, John F. Kennedy Presidential Library and Museum; below, KS.)

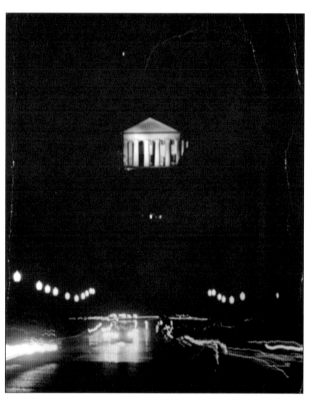

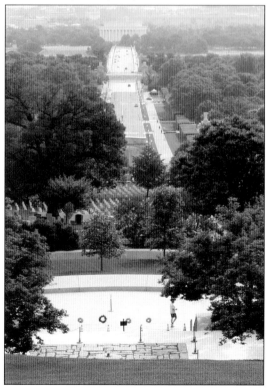

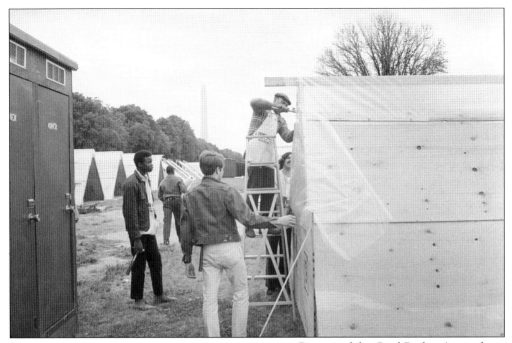

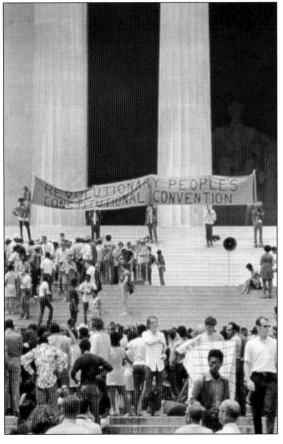

Passage of the Civil Rights Act and Voting Rights Acts in the mid-1960s led to a new era of civic activism focused on poverty and opposing the Vietnam War. The Lincoln Memorial continued to be a setting for these events. After Dr. King's assassination in April 1968, his followers began an extended anti-poverty demonstration by inviting thousands of supporters to come to Washington to build and occupy a temporary encampment along the Reflecting Pool called "Resurrection City." The protest culminated in a Solidarity Day rally at the memorial on June 19, which was attended by over 50,000 people and featured speeches by Rosa Parks and other civil rights leaders. On this same date in 1970, the Black Panther Party held a smaller rally at the memorial promoting a Revolutionary Peoples' Constitutional Convention. (Both, LOC.)

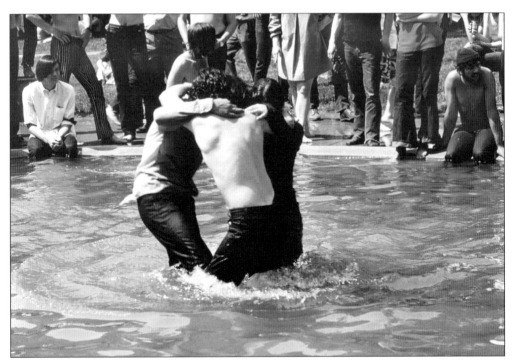

Demonstrators also gathered at the memorial—sometimes plunging into the Reflecting Pool, as in this 1970 photograph—to protest the Vietnam War, the National Guard's killing of four student demonstrators at Kent State University, and other grievances. In the predawn hours of May 9, 1970, shortly after the Kent State massacre, Pres. Richard Nixon famously made a spontaneous visit to the memorial to converse with protesters holding vigil. (NPS.)

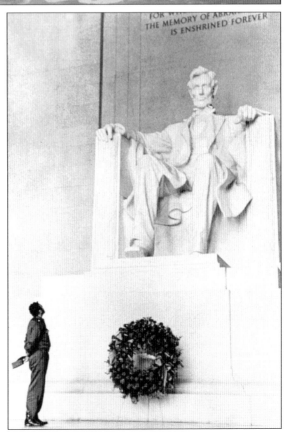

The Lincoln Memorial has long been a popular destination for visiting diplomats and other foreign guests. During an 11-day visit to the United States in 1959 and just two months after assuming power in Cuba, Fidel Castro laid a wreath in front of the memorial's statue. Castro was a fan of Lincoln and reportedly displayed a bust of him in his office. (CPA Media Pte. Ltd./ Alamy Stock Photograph 2B035JC.)

Soviet cosmonaut Gherman Titov (left) visited Washington in May 1962 to address the Committee on Space Research. His host, American astronaut John Glenn (center), took him to several sites in the area, including the Lincoln Memorial. Titov was the second human to orbit Earth, in August 1961. Glenn was the first American to do so, in February 1962. (SPUTNIK/Alamy Stock Photograph B93G08.)

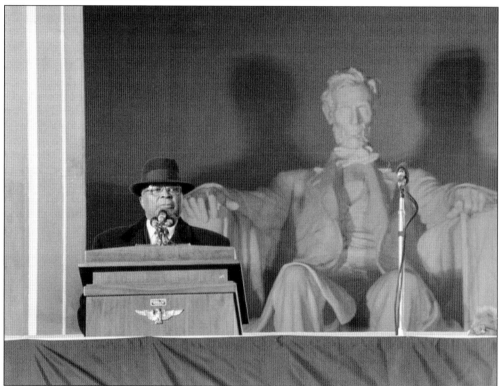

Many presidents have found it politically useful to suggest parallels between themselves and Lincoln. Indeed, since Jimmy Carter, newly elected presidents have always included an event at the Lincoln Memorial in their inaugural festivities. Upon arriving in Washington on January 19, 1977, President Carter held a prayer service at the memorial with the Rev. Martin Luther King Sr., shown here. (LOC.)

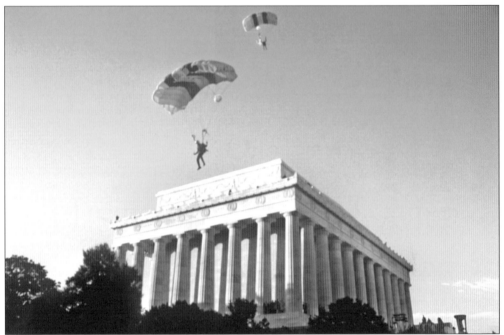

Pres. Ronald Reagan's 1981 inaugural festivities included a light show and musical performances at the Lincoln Memorial. Eight years later, Pres. George H.W. Bush's inaugural festivities included a parachute jump by the US Army Golden Knights in honor of his heroism as a World War II bomber pilot (above). In 2001, Pres. George W. Bush held a celebration at the memorial with musical acts. In 2009, a star-studded performance kicked off the festivities for Pres. Barack Obama. On the eve of their 2021 inauguration, Pres. Joseph Biden and Vice Pres. Kamala Harris presided over a somber ceremony at the Reflecting Pool in memory of the victims of the COVID-19 pandemic. (Above, LOC; below, NPS.)

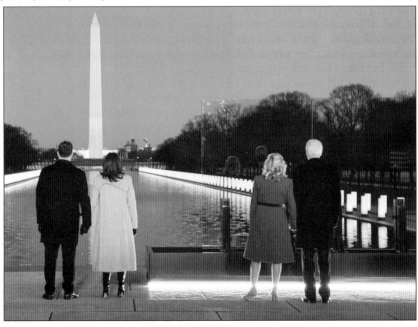

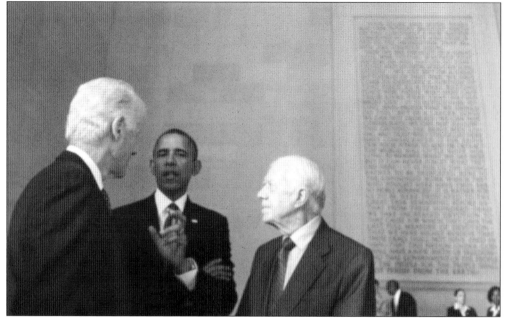

On August 28, 2013, the memorial was the site of the culmination of weeklong events commemorating the 50th anniversary of the 1963 March on Washington. President Obama was joined by former presidents Jimmy Carter and Bill Clinton and many political and civil rights leaders in a Let Freedom Ring ceremony. (NA.)

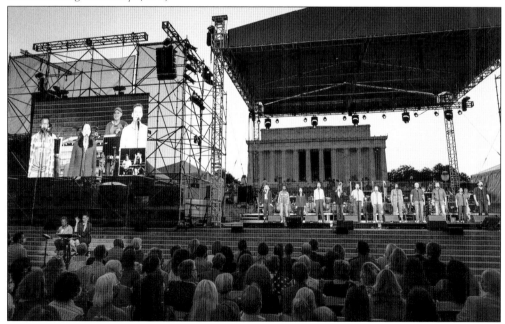

On September 10, 2021, on the 20th anniversary of the September 11 terrorist attacks and coinciding with the resumption of live performing arts following COVID-19 closures, Ford's Theatre Society presented a free public concert by the cast of the Broadway musical *Come from Away*, which shows how residents of a small Canadian town provided hospitality to travelers after their international flights were grounded there following the attacks. (Scott Suchman.)

Seven

CULTURAL ICON

The Lincoln Memorial is one of this nation's iconic landmarks, equal in stature to the Statue of Liberty, Gateway Arch, Mount Rushmore, and Golden Gate Bridge. It is a bucket-list destination for many travelers and one of the most visited historic sites in the country. It is a destination for families, school students, visiting diplomats, and other groups. These pilgrims visit the memorial for a variety of reasons—to experience one of the country's most important national treasures, to pay tribute to a historically consequential leader, and to quietly contemplate what Lincoln's example can teach the rest of us.

For other people, especially those living in the Washington area, the Lincoln Memorial is a backdrop to daily life. In the memorial's early years, children splashed in the Reflecting Pool during the summers and skated on its frozen surface in winter. In modern times, outdoor enthusiasts play soccer, volleyball, or baseball on nearby fields. Spontaneous and planned walks, runs, and bike rides occur along routes surrounding the memorial and nearby National Mall.

Because of the Lincoln Memorial's popularity and historic significance, it has also become a cultural landmark celebrated around the world and incorporated into popular culture. Its likeness has been featured on postage stamps and currency. It is the backdrop to news shows, automobile advertisements, and political cartoons. It has also been featured in numerous film and television productions.

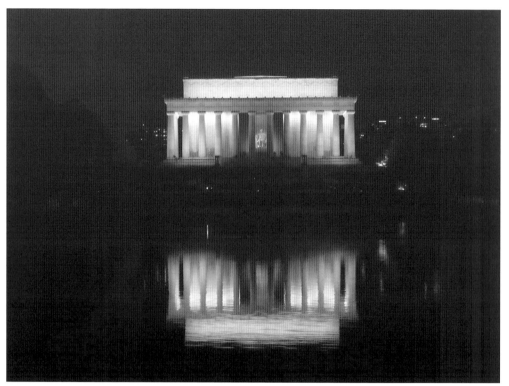

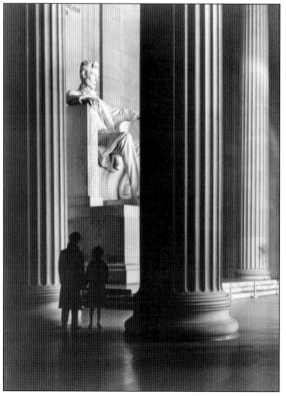

Despite the designed openness of the memorial, which makes it accessible day or night, it was not initially illuminated, so most visitors came during daylight hours. This changed in 1929 with the addition of lights, after which nighttime visits became popular. The shadowy appearance of the building and lit Lincoln statue makes a late-evening visit to the memorial especially intimate for many people. With the memorial elevated above the surrounding landscape, a nighttime visit also offers a nice vantage point to see the light-bathed Reflecting Pool, Washington Monument, and other nearby features of the National Mall. (Above, KS; left, LOC.)

Annual visitation to the Lincoln Memorial doubled in the 1930s with the increasing promotion of Washington tourism and the reinvigoration of the Lincoln legend. Pres. Franklin Delano Roosevelt helped trigger interest in the memorial when he aligned his political views with those of Lincoln. In addition, Carl Sandburg completed his popular six-volume biography of Lincoln in 1939, earning the second of his three Pulitzer Prizes for the effort. (LOC.)

As the 20th century unfolded, the Lincoln Memorial became a popular backdrop for springtime photographers capturing images of blossoming cherry trees. These were imported from Japan in the early part of the century, thanks to the efforts of First Lady Helen Taft and writer/photographer Eliza Scidmore. From these original gifts grew the proliferation of cherry trees and a corresponding proliferation of springtime blossom watchers that continues today. (NA.)

LINCOLN MEMORIAL AND CHERRY BLOSSOMS, WASHINGTON, D. C.

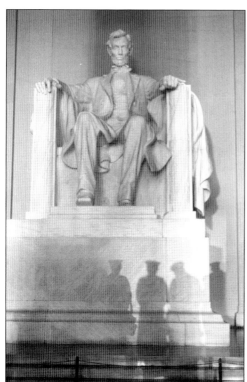

During World War II, soldiers passing through Washington on their way to battle stopped by the memorial to find inspiration in the venerated statue of Lincoln. Through the years, military personnel—whether going to war or not—continued this tradition of paying homage. This image shows the shadows of a joint honor guard cast on the Lincoln statue in 1989. (NA.)

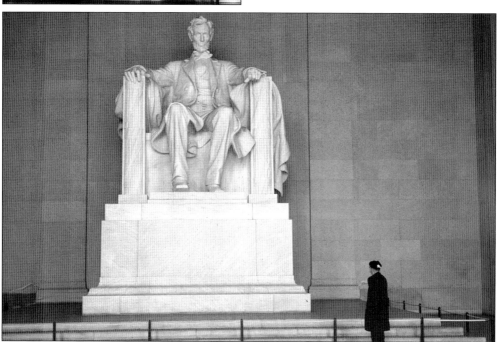

Visitation continued to increase in the years following World War II, from 2.5 million people in 1950 to 4.3 million in the 1976 bicentennial year. As is often the case with such attractions, the increasing popularity had the negative effect of limiting the opportunity for visitors to enjoy the quiet, personal experience they understandably seek. (NPS.)

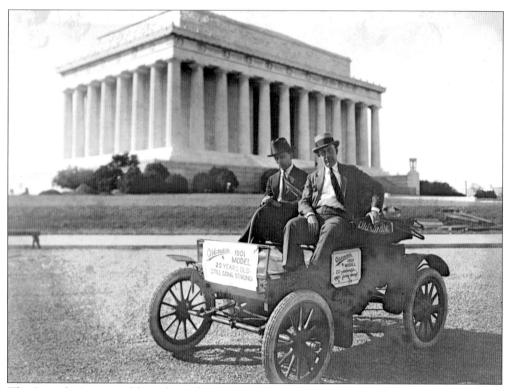

The Lincoln Memorial has always been a popular backdrop for photography that not only commemorates individual visits and historic events, but also promotes a wide range of commercial products. The above picture, taken in 1921 or 1922, shows two men sitting in a 1901 model Oldsmobile southeast of the memorial. The sign advertises that the car is "still going strong" after 20 years. The image below, also probably taken in the 1920s, features a Semmes Motor Company truck. A wheel-bound advertisement for the Post cereal company, the vehicle sits along the back (west) side of the Lincoln Memorial. (Both, LOC.)

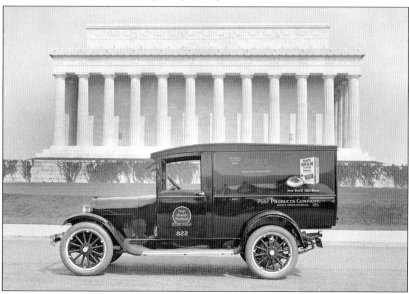

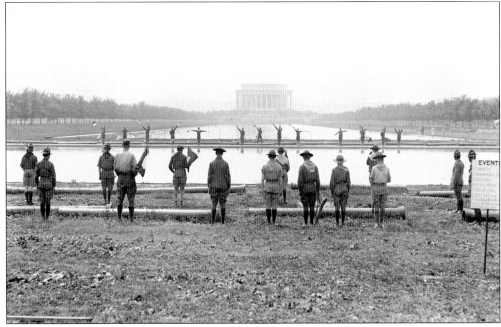

The long Reflecting Pool and the smaller Rainbow Pool between it and the Washington Monument not surprisingly became popular sites for a variety of spontaneous activities by different individuals and groups. This 1923 photograph shows two groups of Boy Scouts communicating using semaphore flags as part of a training program in an array of Scout skills. (LOC.)

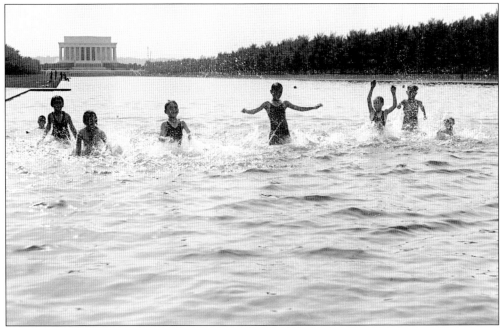

Although swimming has technically never been allowed in the pools, people still do so on occasion. These children took to the shallow waters to cool off on a hot summer day in 1929. In later years, such activity was not as appealing due to periodic parasite outbreaks, algae growth, and fecal material from ducks and other waterfowl. (LOC.)

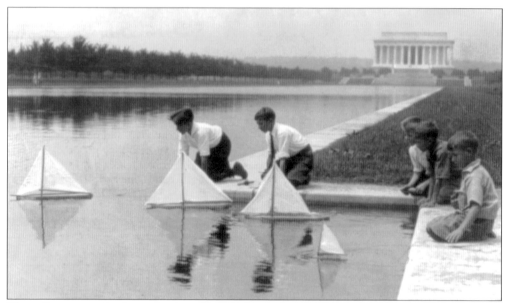

The reflecting pools also make for a fun and relatively safe setting for children playing with toy sailboats. Water basins such as these do not need to be deep to produce a nice reflection. The Lincoln Memorial pools' maximum depths are less than three feet, which makes them reasonably safe even for people who accidentally fall in. (LOC.)

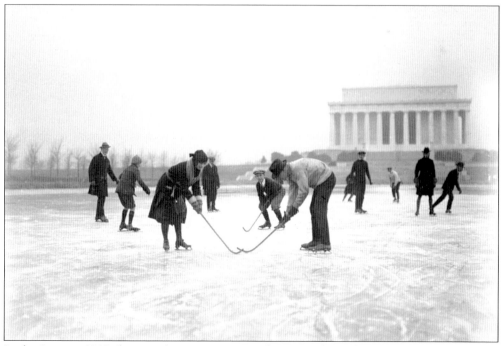

In this January 1922 photograph, winter sports enthusiasts take to the frozen Reflecting Pool to play hockey and otherwise skate around. The pool's shallowness allows water to freeze quickly on cold days. This is another activity that was more likely to have happened just after the completion of the pools than in modern times. (LOC.)

This woman and her four-legged caddy are visiting the grounds southeast of the Lincoln Memorial in 1923 to hit golf balls. While the closest golf course is 1.5 miles away in East Potomac Park, nearby recreation fields have become the site for spontaneous and planned contests in baseball/softball, soccer, field hockey, volleyball, polo, and other sports. (LOC.)

Today, a trio of playing fields runs end to end in an east-west direction south of the Reflecting Pool between the Korean War Memorial and the World War II Memorial. Collectively known as the JFK Hockey Fields, they are used for field hockey, Frisbee, yoga, and a wide range of other activities. (KS.)

The picturesque paths on and around the National Mall are popular with walkers and runners. Many organized running races in Washington plan their routes so that participants see the Lincoln Memorial. Here, runners pass by the memorial near the 10-mile mark of the 1987 Marine Corps Marathon before heading toward the US Capitol. (NA.)

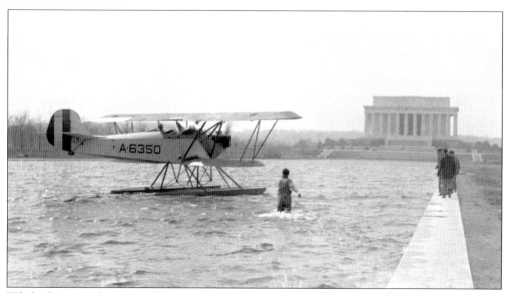

While the grounds surrounding the Lincoln Memorial have been busy through the years with tourists, outdoor enthusiasts, and other visitors, the skies above can also be active. In a scene one might expect to see in a movie, a seaplane flew around the mall and then landed in the Reflecting Pool in 1923. (LOC.)

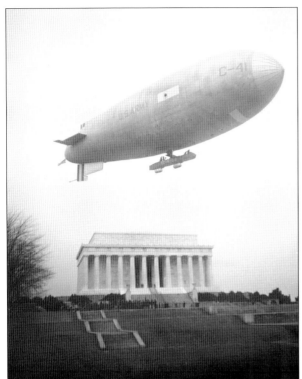

More than one of Goodyear's signature blimps have visited the National Mall through the years. US Army pilots also periodically flew blimps overhead during training exercises. One of them, shown here, landed near the memorial in 1930. This was a special flight to celebrate Abraham Lincoln's birthday that culminated with the crew placing a wreath at the memorial. (LOC.)

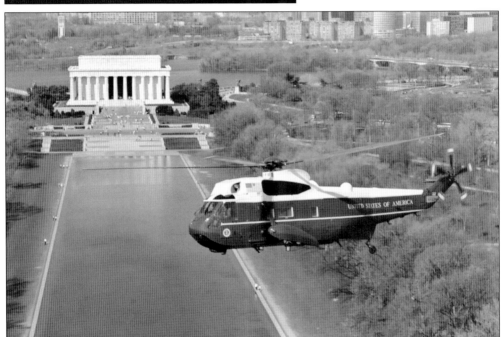

In more recent years, flights departing from and arriving at Washington National Airport often pass by the memorial on a path along the Potomac River. Helicopter traffic is also common. Shown here is the US presidential helicopter—Marine One—leaving the White House during the latter days of Ronald Reagan's presidency. (NA.)

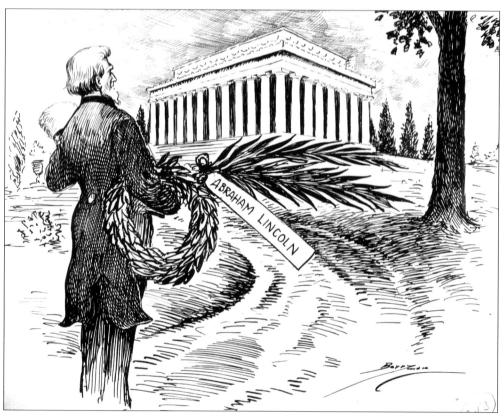

It did not take long after its opening for artists to invoke the Lincoln Memorial in their storytelling. Twenty years after cartoonist Clifford Berryman drew a sketch featuring Theodore Roosevelt with a bear, which led to the invention of the teddy bear stuffed animal, he commemorated the opening of the Lincoln Memorial in May 1922 with this cartoon depicting Uncle Sam carrying a wreath to the just-completed monument. (NA.)

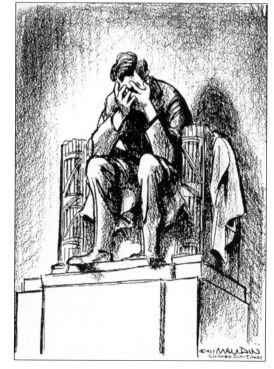

Bill Mauldin was a cartoonist best known for depicting the life of soldiers in World War II. Years later, while working for the *Chicago Sun-Times*, he drew perhaps his most famous cartoon. It was published on November 23, 1963, and depicted Abraham Lincoln grieving the news of Pres. John F. Kennedy's assassination the previous day. (©1963 Bill Mauldin Estate LLC.)

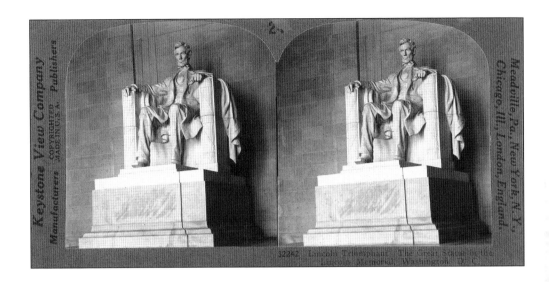

Stereographs, developed in the mid-19th century, represent an early type of 3D photography. When two nearly identical images are placed side by side and viewed through a device called a stereoscope, the merged images appear as a single, three-dimensional one. Stereographs were effective tools for education and entertainment. They also made for popular souvenirs of tourist attractions, such as the Lincoln Memorial. The Keystone View Company designed both of the stereographs shown here, around 1928 (above) and 1935 (below). While these early stereoscopes eventually became obsolete, a special-format version called View-Master later became popular and is still produced today, mostly for children. (Both, LOC.)

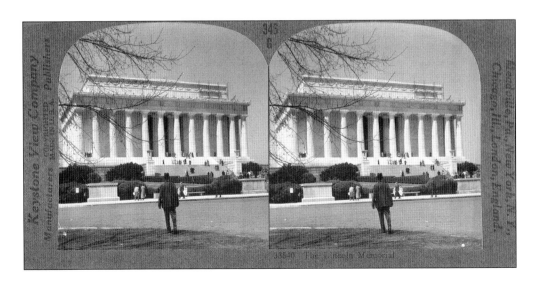

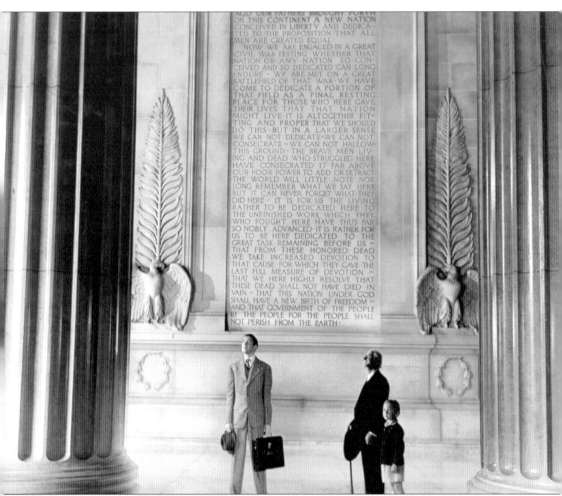

The Lincoln Memorial (or its likeness) has been featured in dozens of movies and television shows, such as the films *Forrest Gump*, *National Treasure*, and *The Day the Earth Stood Still*. For *Forrest Gump*, about 1,500 extras were on hand during the two-day filming of an anti-war rally scene at the memorial. Using computer-generated imagery, special effects experts multiplied the extras to create an apparent crowd of several hundred thousand people. In some cases, such as the film *Mr. Smith Goes to Washington* (shown here with lead actor James Stewart as Jefferson Smith standing at left) and the television show *Gomer Pyle, USMC*, key characters visit the memorial for inspiration and soul searching. Having been advised that the National Park Service did not want any filming at the memorial, the director of *Mr. Smith* sent a large camera crew elsewhere in the city as a decoy so he could quickly and quietly film this scene. (Album/Alamy Stock Photograph P0W06B.)

The Federal Reserve System—the United States' central banking system—was established in 1913. It issued its first five-dollar note (bill) the following year. The "fin," as it was often called, featured a portrait of Abraham Lincoln on the front and, on the back, scenes of Christopher Columbus and his crew sighting land in the "New World" and Pilgrims landing at Plymouth Rock (above). In 1929, under the Series of 1928, the vignettes on the back were replaced with a rendering of the Lincoln Memorial. The below image shows a version issued in Hawaii during World War II. The "Hawaii" overprint was a safety measure; if the Japanese invaded the islands and tried to take money, the US government could declare these overprinted versions worthless. (Both, KS.)

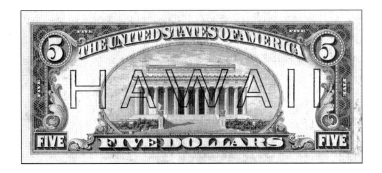

The first Lincoln penny appeared in 1909—the centennial year of Abraham Lincoln's birth. It featured a portrait of Lincoln on the front and stalks of wheat on the back (above). In 1959—the sesquicentennial of Lincoln's birth—the back design was changed to the Lincoln Memorial. It stayed this way until the bicentennial of Lincoln's birth, in 2009, when the memorial was replaced by one of four scenes from Lincoln's life—a log cabin, Lincoln reading while taking a break from splitting rails, Lincoln as a lawyer, or the Capitol dome. The current back design—a Union shield representing the states that joined during Lincoln's tenure—was introduced the following year. (Both, KS.)

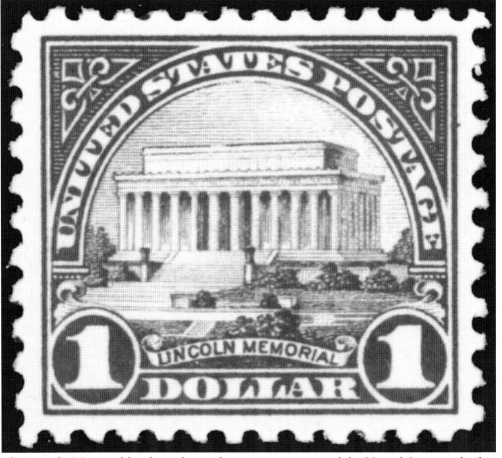

The Lincoln Memorial has been featured on postage stamps of the United States and other countries. C.A. Huston of the US Bureau of Engraving and Printing designed the first of these (above). This $1 stamp was approved on May 30, 1922 (the day the Lincoln Memorial was opened) and released on February 12 (Lincoln's birthday) in 1923. On May 30, 1959—the same year that the design on the back of the penny changed from wheat to the Lincoln Memorial in honor of the 150th anniversary of Lincoln's birth—the US Postal Service released a 4¢ stamp highlighting the head of the memorial's statue. The one shown below is attached to a commemorative first day cover. (Both, KS.)

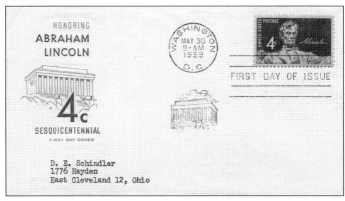

Not surprisingly considering its popularity, the Lincoln Memorial has been featured in a wide variety of collectible souvenirs: spoons, magnets, snow globes, calendars, glasses, figurines, ashtrays, keychains, pencils, thimbles, salt and pepper shakers, Christmas tree ornaments, bottle openers, pencil sharpeners, and more. This commemorative plate celebrates the Lincoln Memorial on the 150th anniversary of Lincoln's birth. (KS.)

For Washington, DC, residents, the Lincoln Memorial is never far away, whether passing by the memorial itself or seeing its image emblazoned on the side of a bus, printed in newspapers, or in promotional materials. Even fans at Washington's home-team baseball games see it when Nationals players come to bat amidst their walk-up music. (KS.)

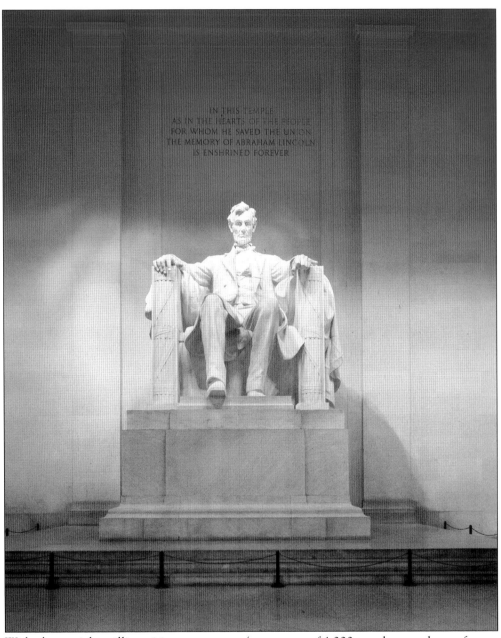

With almost eight million visitors every year (an average of 1,000 people every hour of every day of the year), the Lincoln Memorial is the most visited site on the National Mall. Why? One reason is its fame. The site is an iconic world-class destination of which most people are aware and want to see. Another reason is its accessibility. The memorial is easy to visit. It is open every hour of every day. It is free, and anyone can walk in unobstructed by doors or security screenings. But the most important reason is the worldwide love and respect for the person the memorial honors. Abraham Lincoln represents what most people aspire to be. He was an ordinary person who overcame profound adversity to maximize his abilities and positively affect the lives of untold millions of people across multiple generations long after his death. The Lincoln Memorial helps people understand what Lincoln accomplished, how he did it, and why it is important. (LOC.)

BIBLIOGRAPHY

Anderson, Brian. *Ford's Theatre*. Charleston, SC: Arcadia Publishing, 2014.

Concklin, Edward F., ed. *The Lincoln Memorial in Washington*. Washington, DC: Government Printing Office, 1927.

Holzer, Harold. *Monument Man: The Life & Art of Daniel Chester French*. New York, NY: Princeton Architectural Press, 2019.

Matthews, James D. *The Lincoln Memorial: An Athenian Temple in Memory of the Great American*. Washington, DC: National Art Service Co., 1934.

McGee, Elaine S. "Colorado Yule Marble—Building Stone of the Lincoln Memorial." *U.S. Geological Survey Bulletin* 2162 (1999): 43.

National Park Service. *Lincoln Memorial: A Guide to The Lincoln Memorial, District of Columbia*. Washington, DC: US Department of the Interior, National Park Service, Division of Publications, 1986.

———. Cultural Landscape Report, West Potomac Park, Lincoln Memorial Grounds. Washington, DC: US Department of the Interior, National Park Service, National Capital Region, 1999.

Sacher, Jay, and Chad Gowey. *Lincoln Memorial: The Story and Design of an American Monument*. San Francisco, CA: Chronicle Books, 2014.

Thomas, Christopher A. *The Lincoln Memorial & American Life*. Princeton, NJ: Princeton University Press, 2002.

Discover Thousands of Local History Books Featuring Millions of Vintage Images

Arcadia Publishing, the leading local history publisher in the United States, is committed to making history accessible and meaningful through publishing books that celebrate and preserve the heritage of America's people and places.

Find more books like this at
www.arcadiapublishing.com

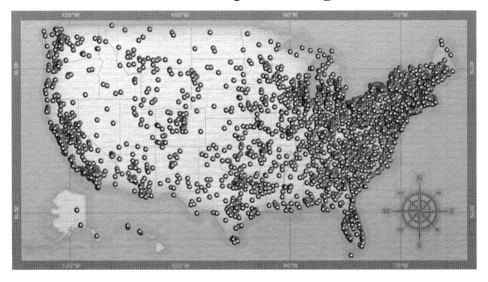

Search for your hometown history, your old stomping grounds, and even your favorite sports team.